SCAN THIS BOOK THREE

Art Direction Book Company, Incorporated

Suggestions for Designing With This Book

1. Screen back objects and use as background images on pages with large text blocks.

2. Montage objects together to create unique forms.

3. Convert scans from grayscale to CMYK, then add color to white areas.

4. Overprint onto flat color with objects printed in a gloss or matte varnish.

5. Foil stamp images in metallics, pearl white, or black.

6. Use the selection of silhouettes to create interesting embossings or laser cuts.

7. Convert scans to GIFS and use to enhance Web sites.

8. Using software such as GIF Builder, create unique Web site animations.

9. Enlarge images to poster size for point—of—purchase or trade show displays.

10. Convert scans to imageset film. Use in slide form to enliven presentations.

11. Project images onto actual three-dimensional objects. Rephotograph to create intriguing effects.

12. Reduce objects and use as part of label or package designs.

13. Repeat as patterns for all types of applications such as gift wrapping and endpapers.

14. Silk screen objects onto t-shirts and sweatshirts.

15. Images from the holiday and graduation sections can be used to make personalized greeting cards.

16. Build your own laboratory with the scientific apparatus.

17. Utilize this book as a reference for illustrating original art work.

18. Challenge yourself and create inventive new uses!

ISBN: 0—88108—205—8
LCCN: 97—074890

Printed in the United States of America

Published by:
Art Direction Book Company, Incorporated
456 Glenbrook Road
Glenbrook, Connecticut 06906

Phone: (203) 353—1441
Fax: (203) 353—1371

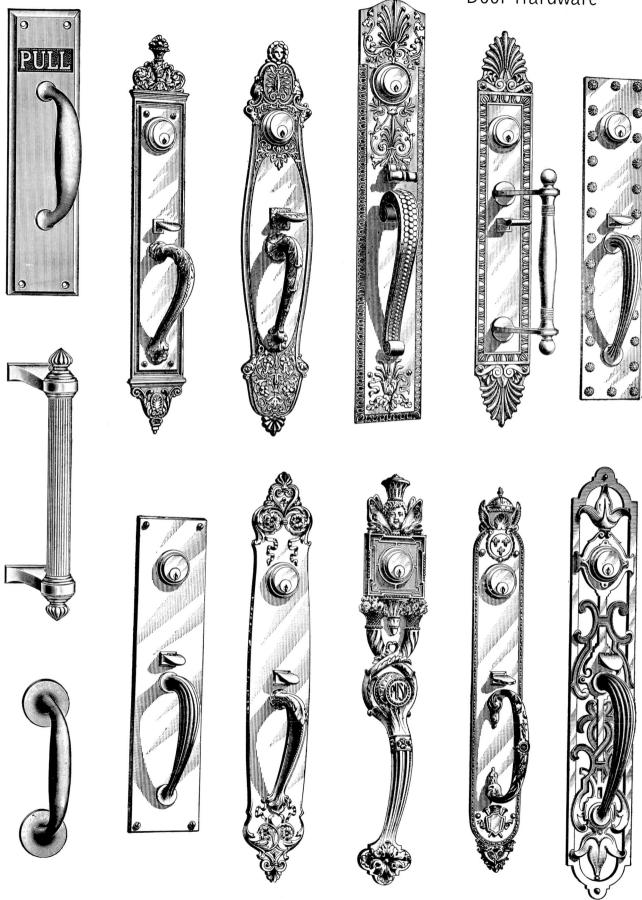

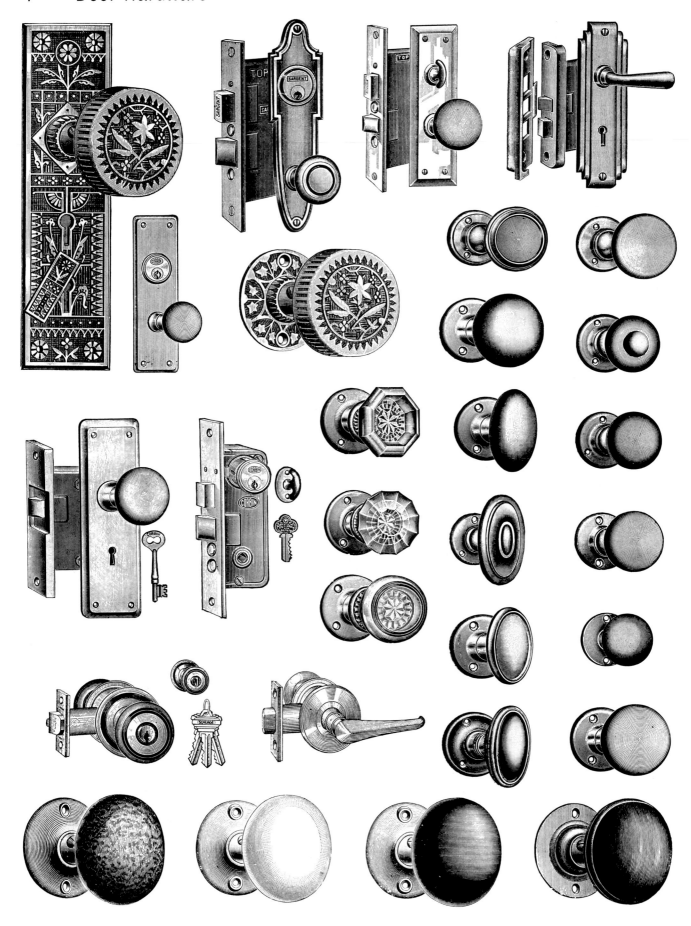

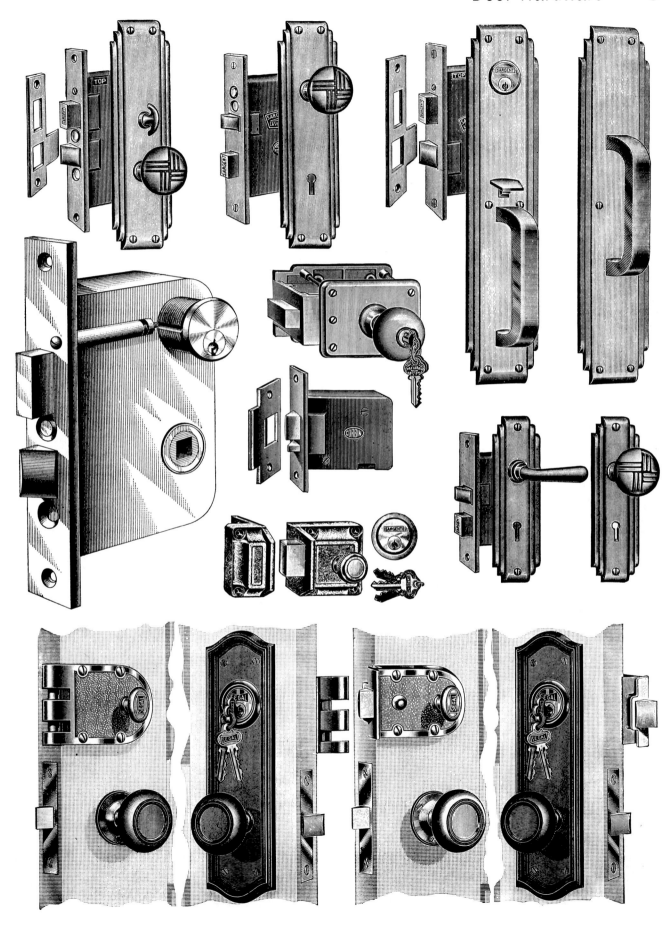

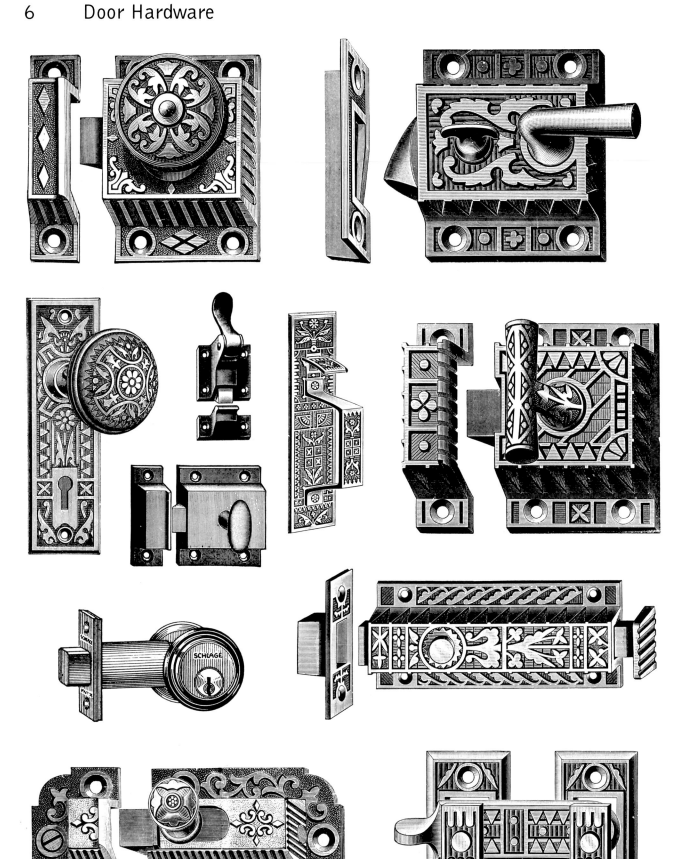

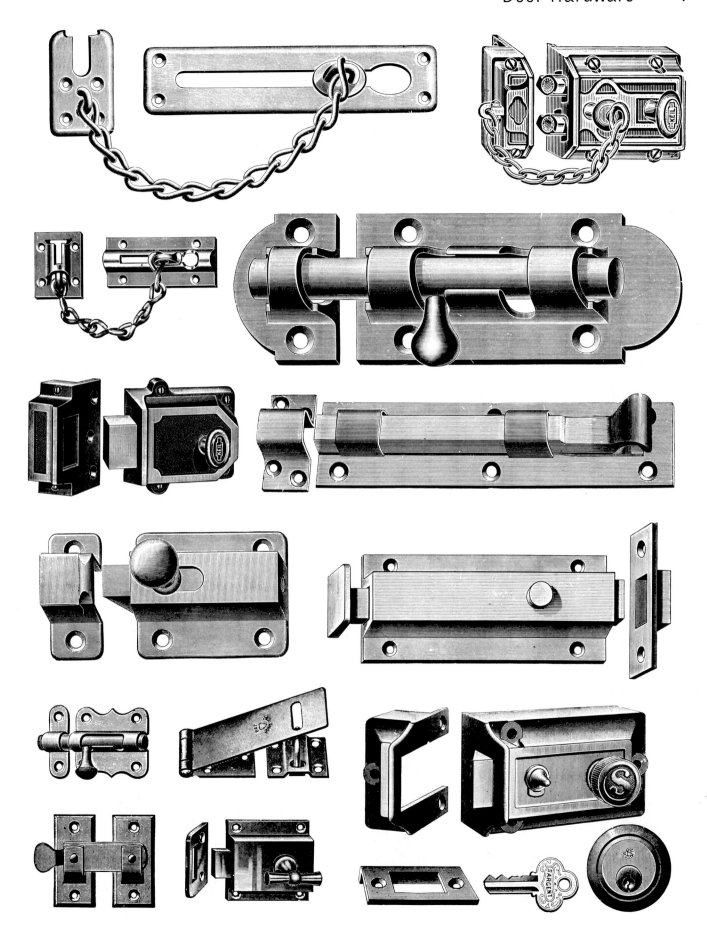

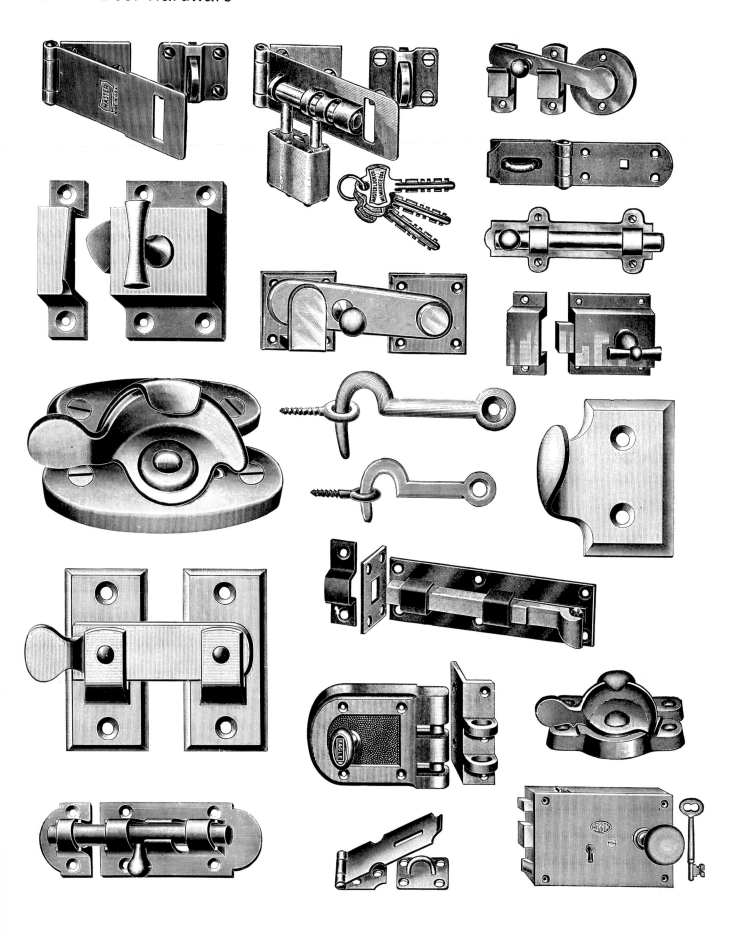

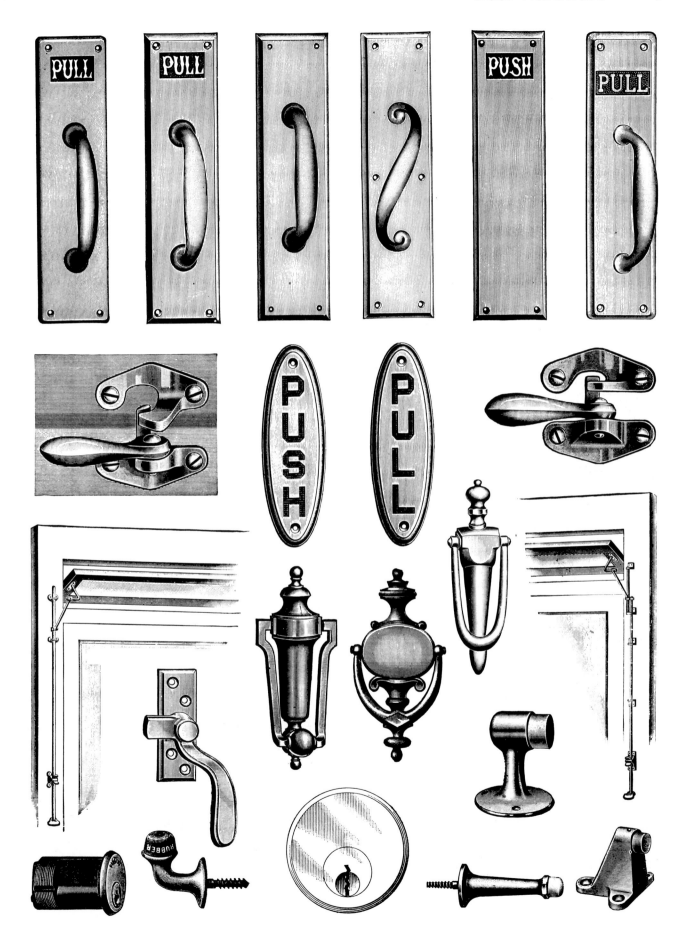

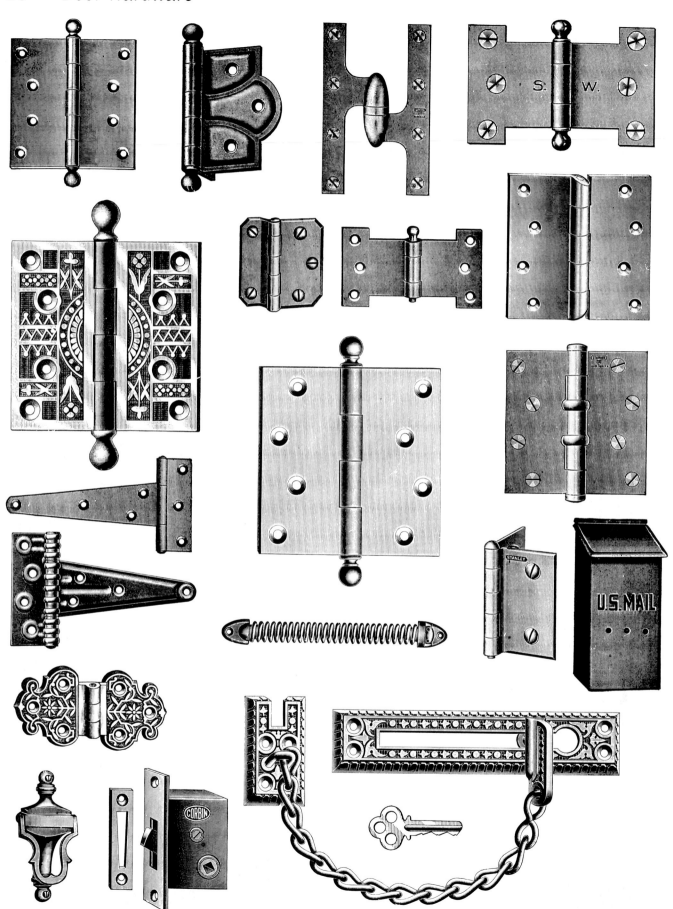

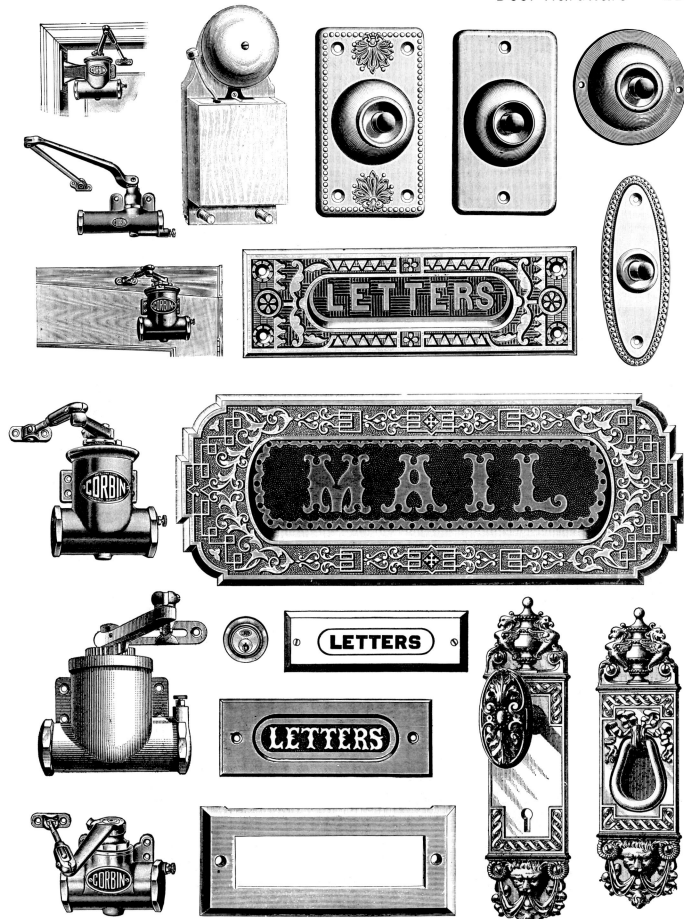

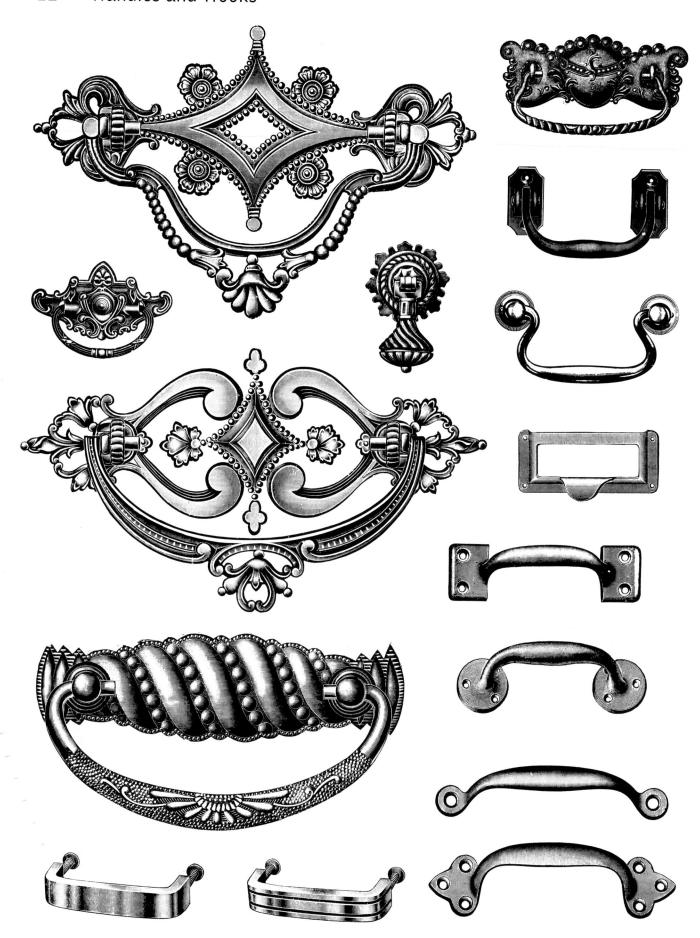

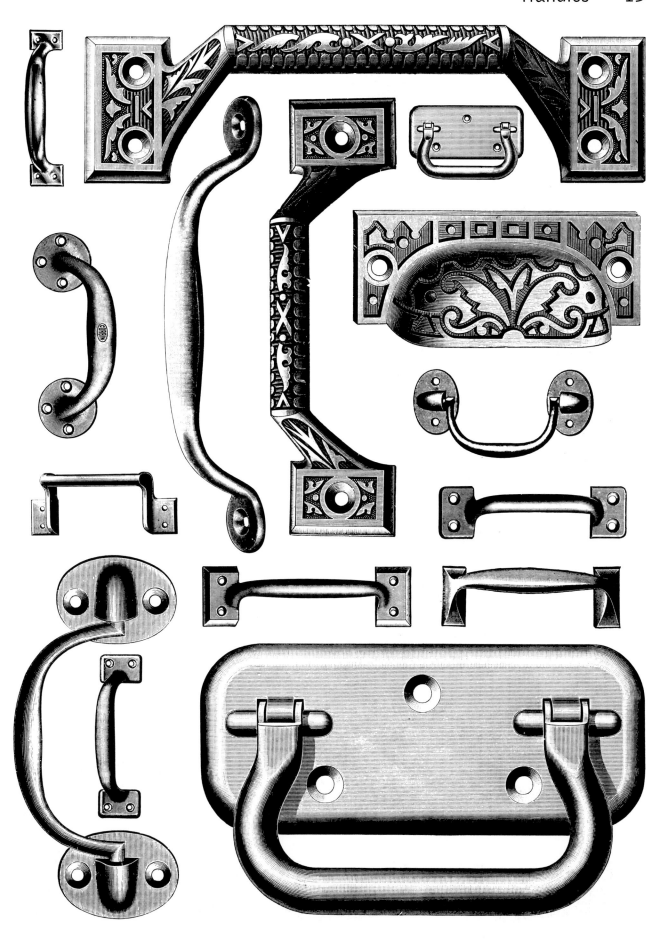

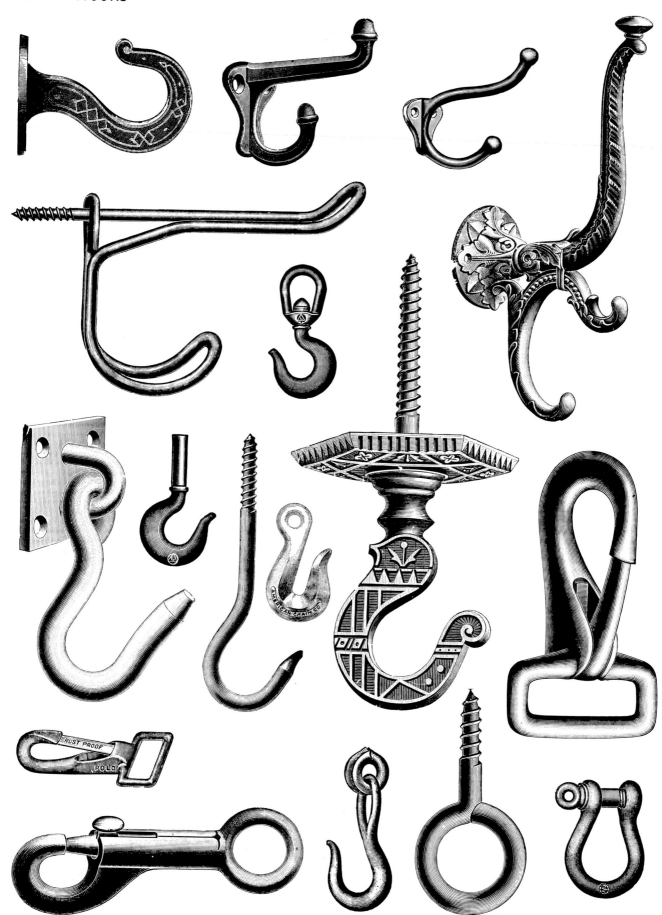

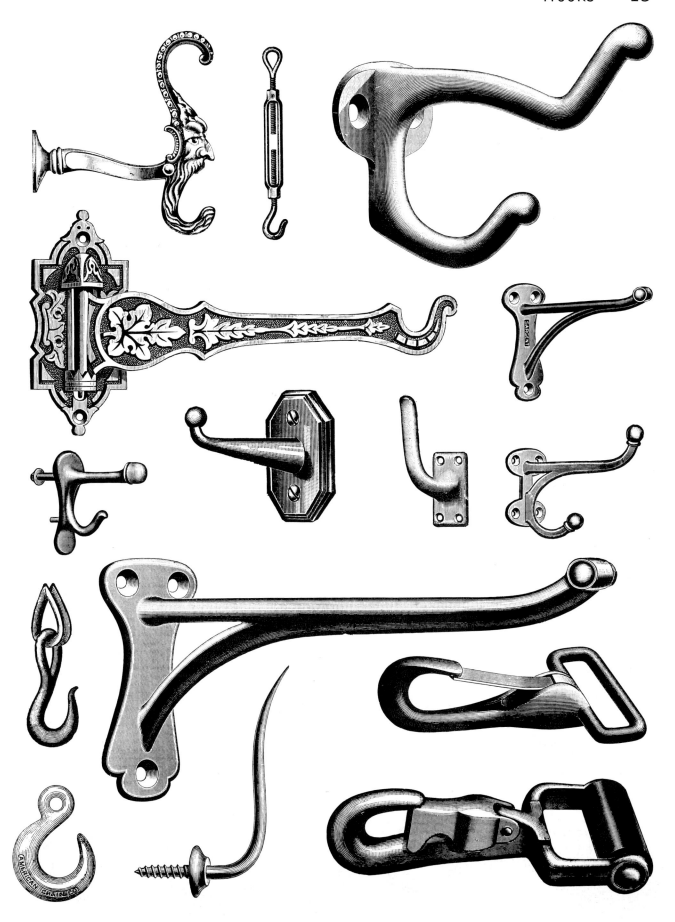

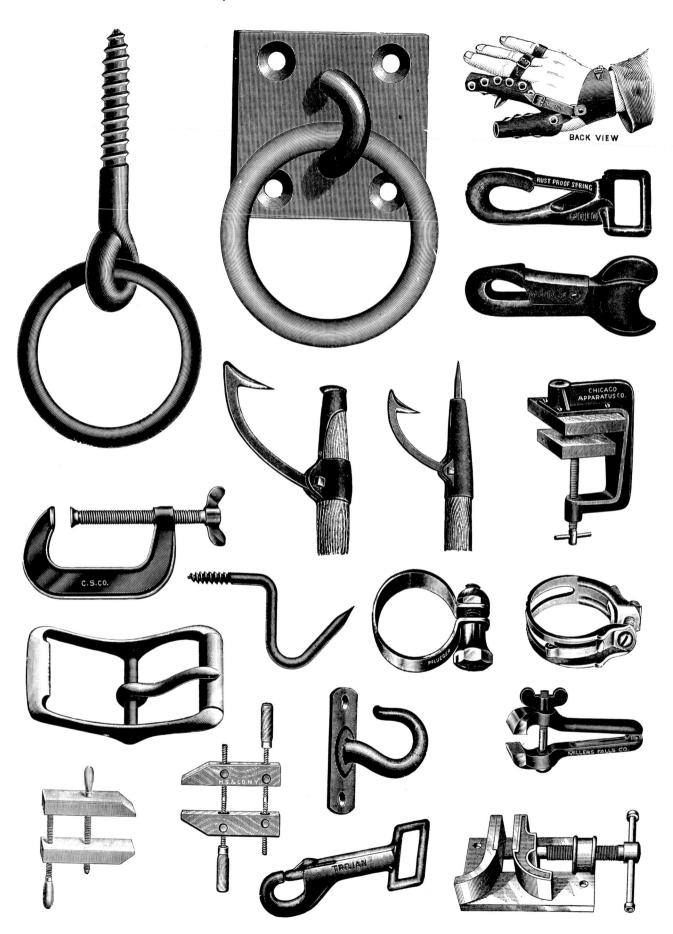

BACK VIEW

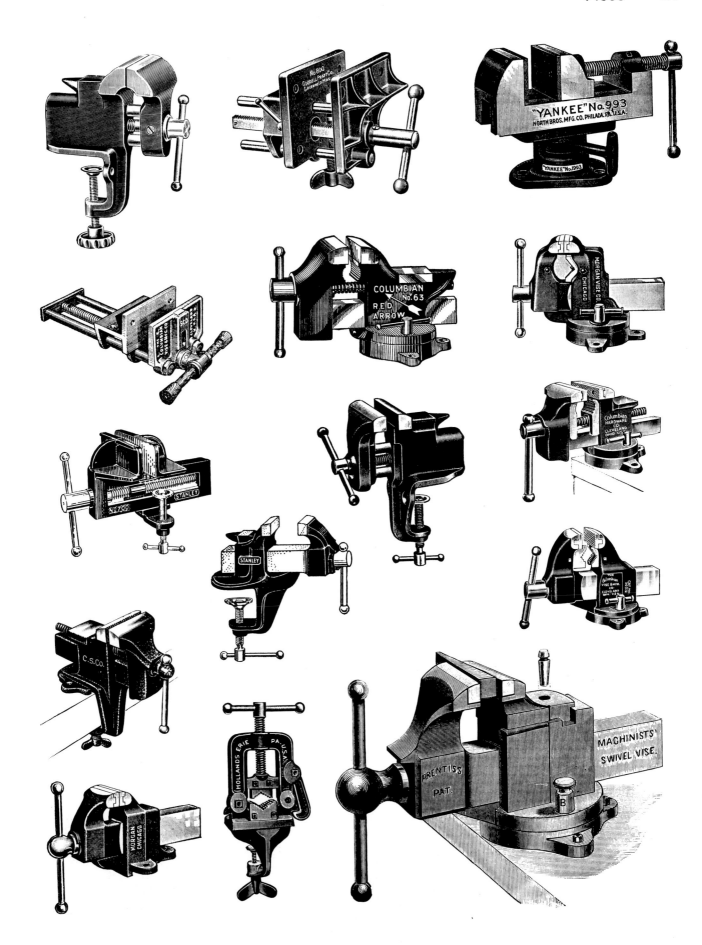

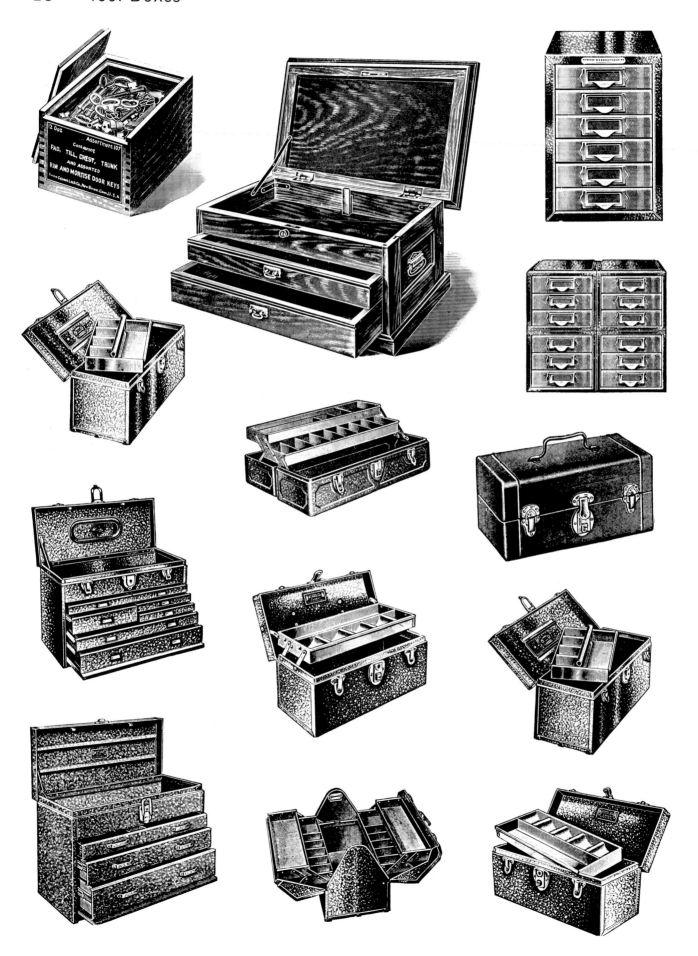

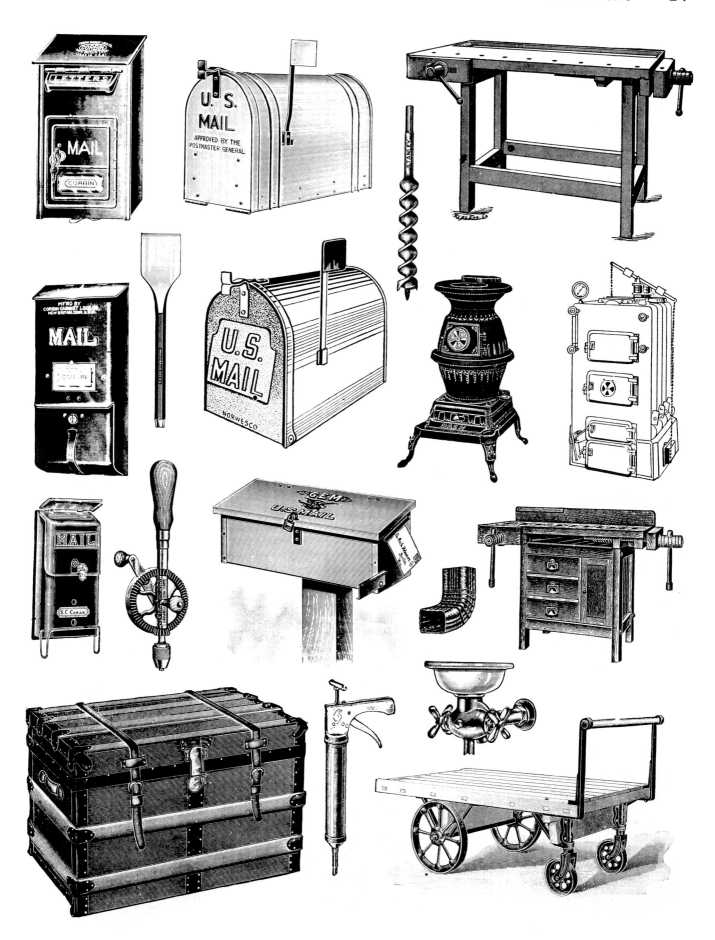

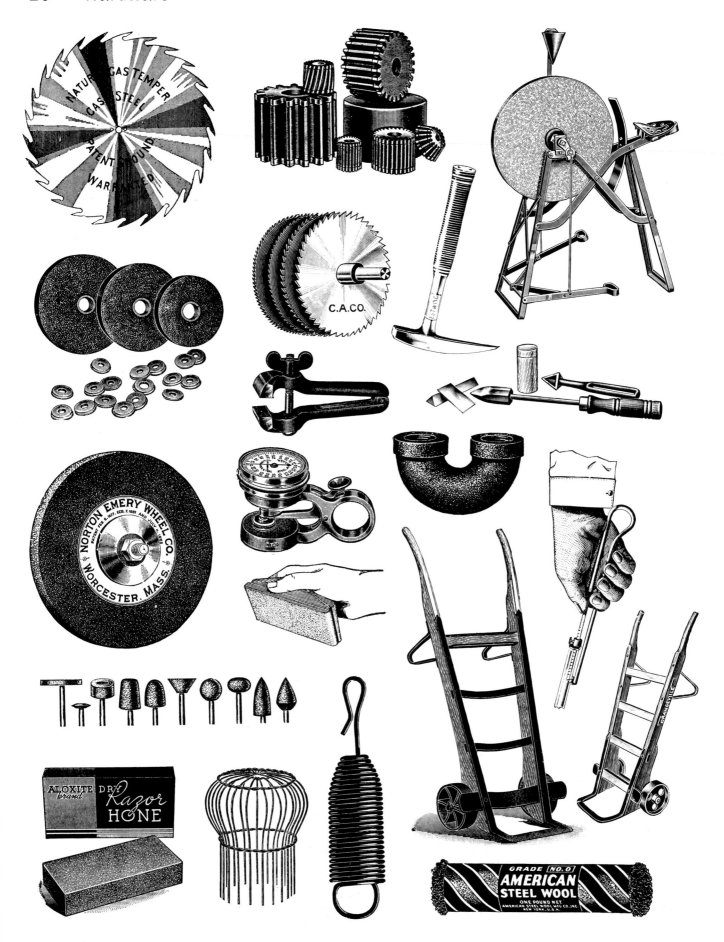

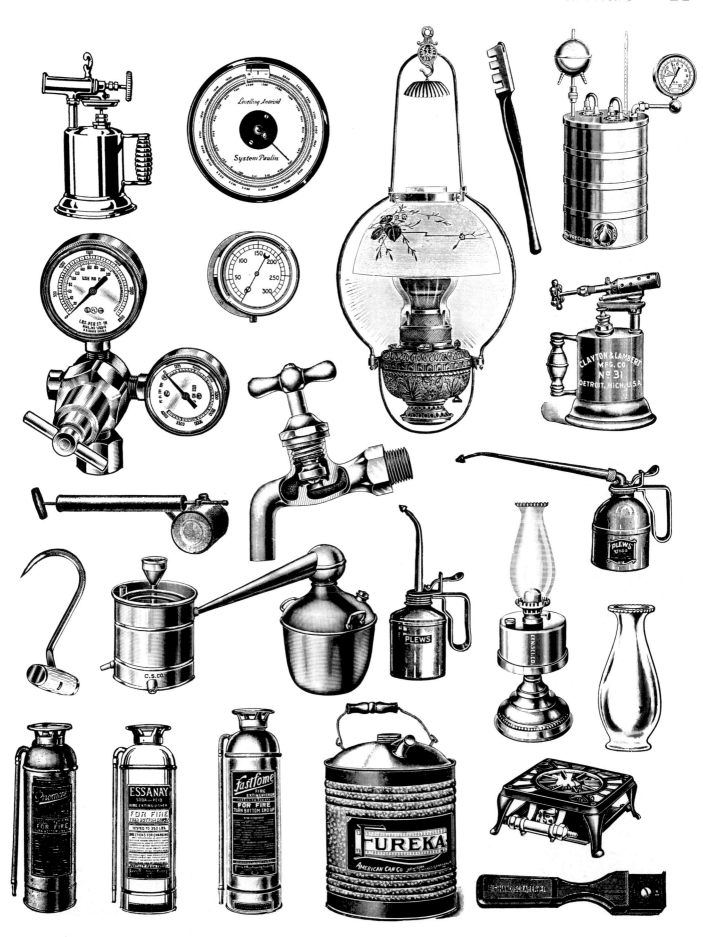

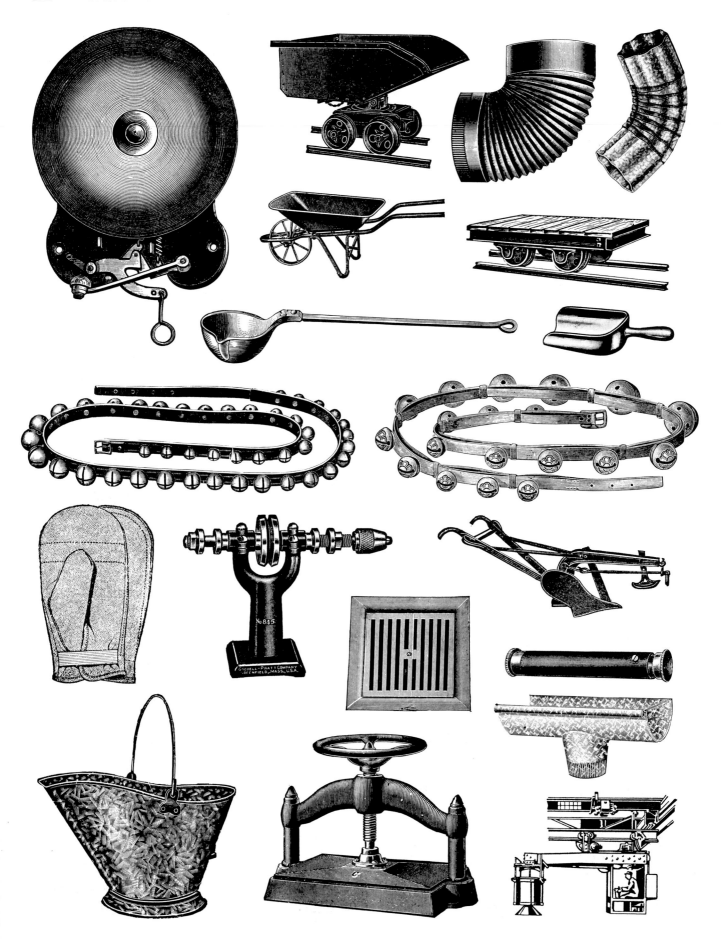

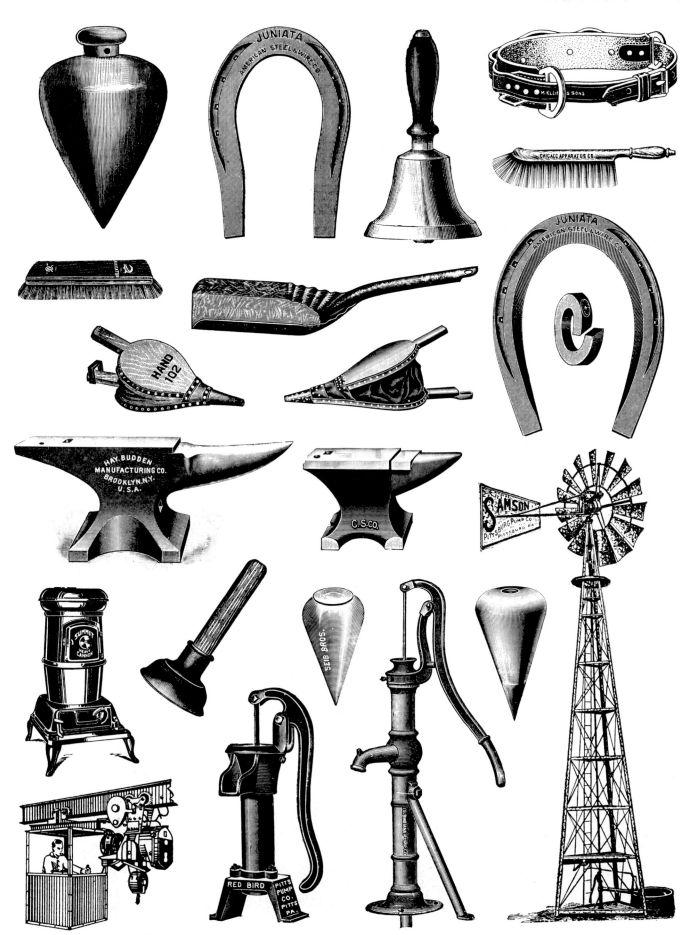

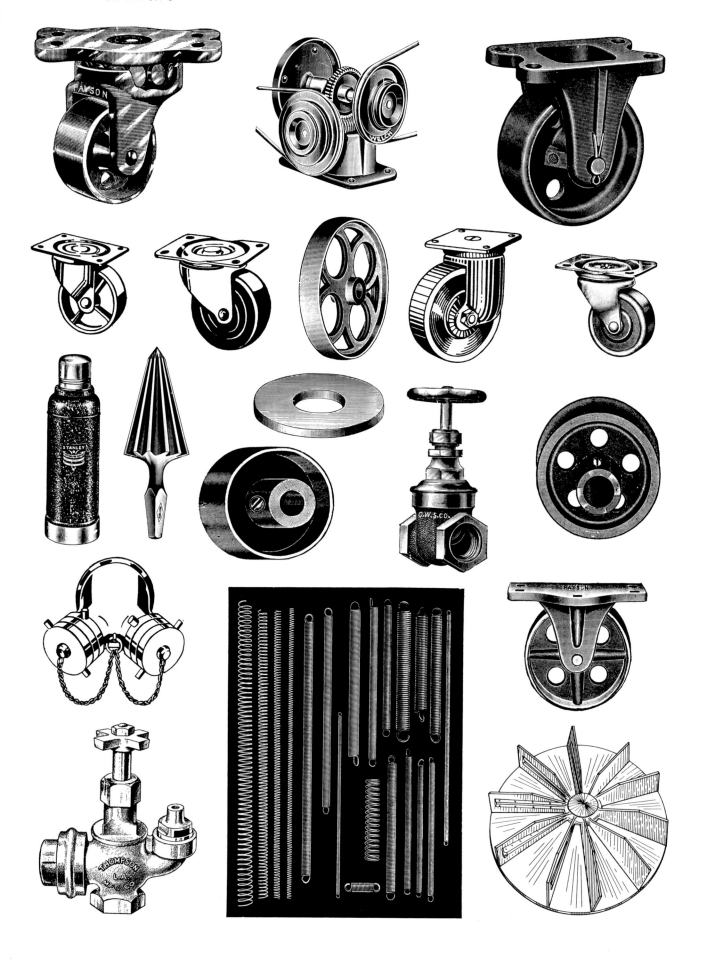

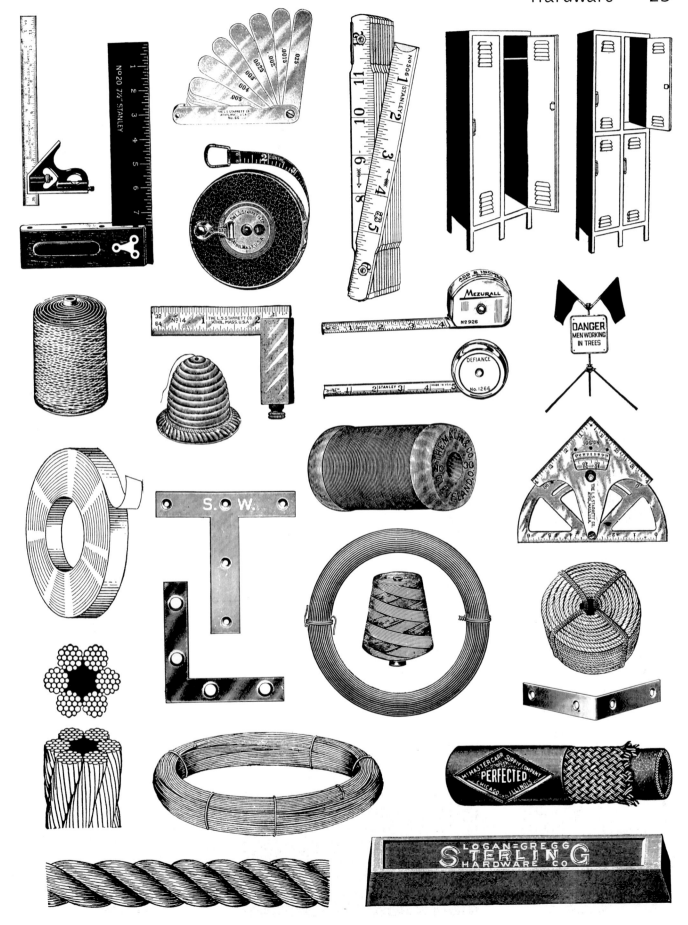

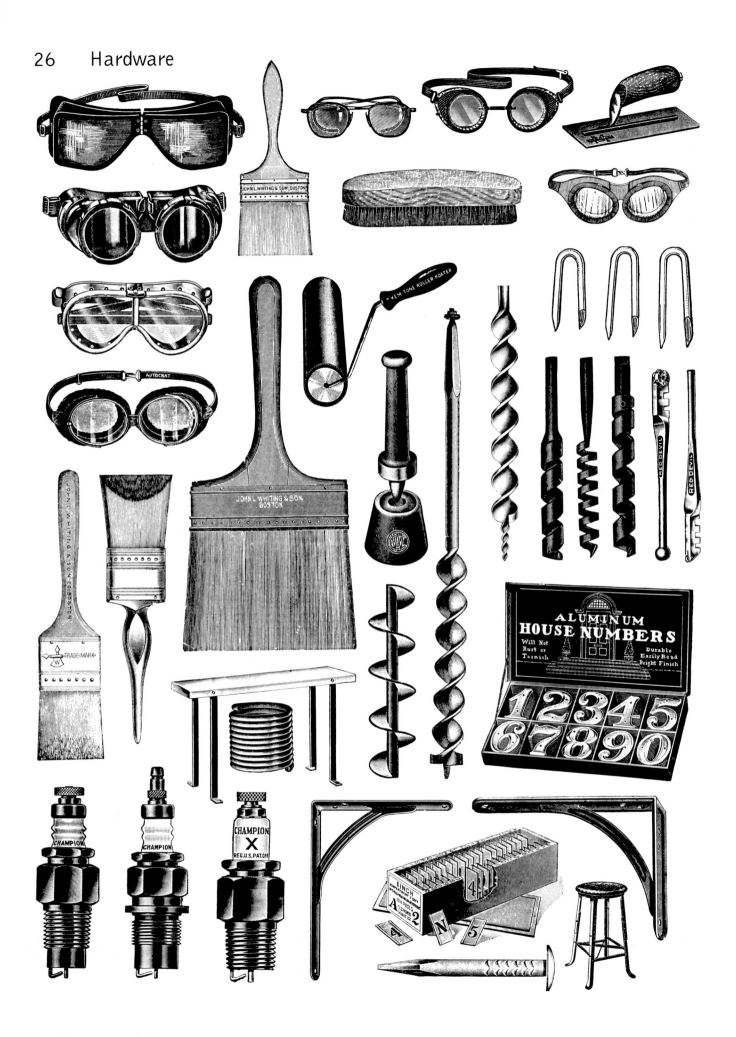

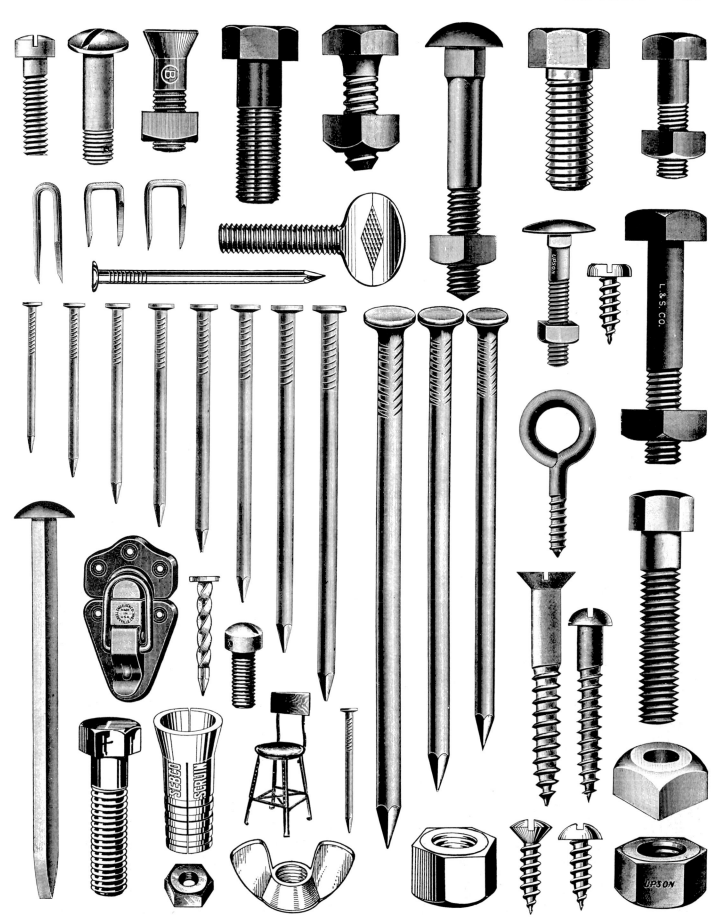

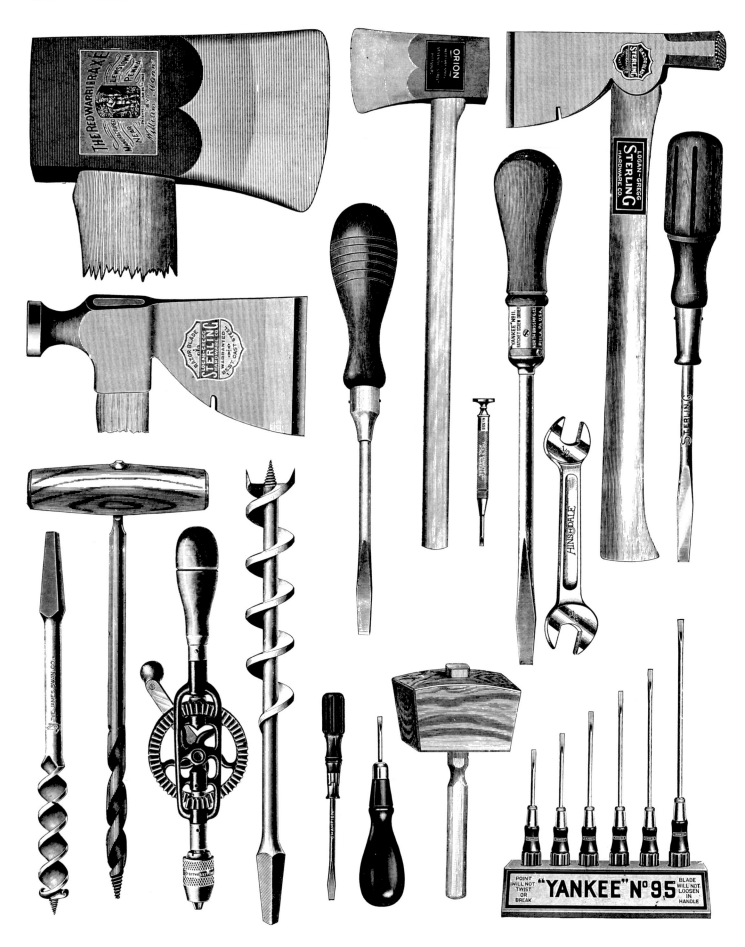

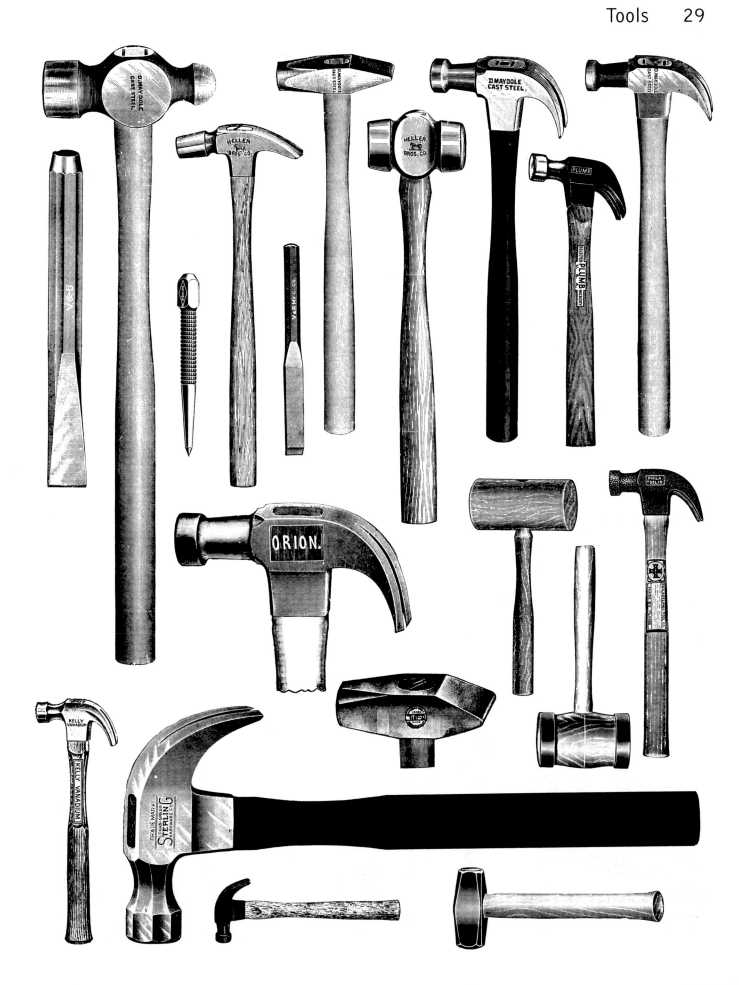

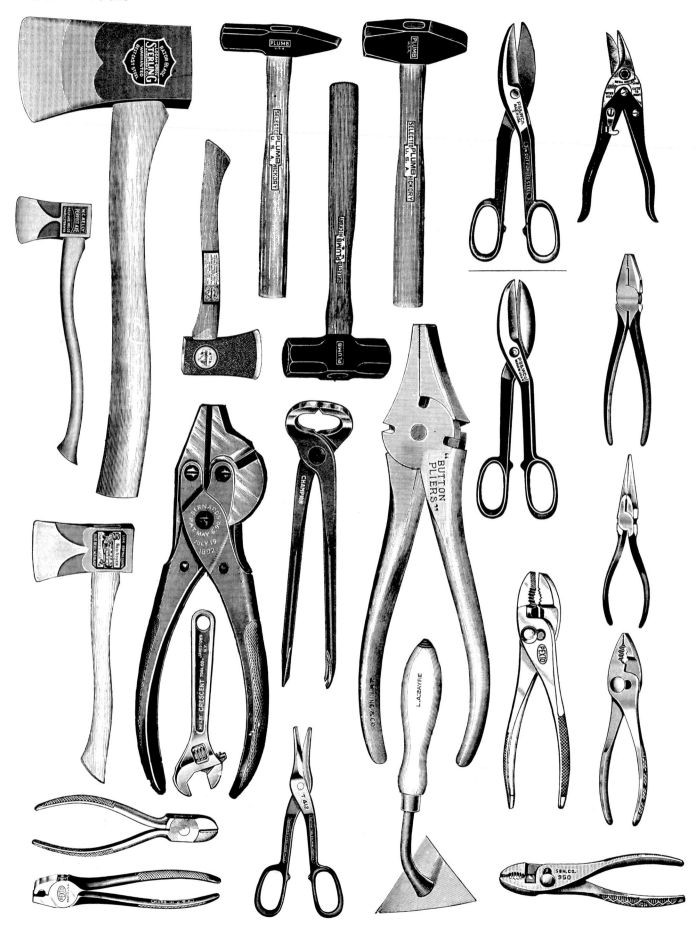

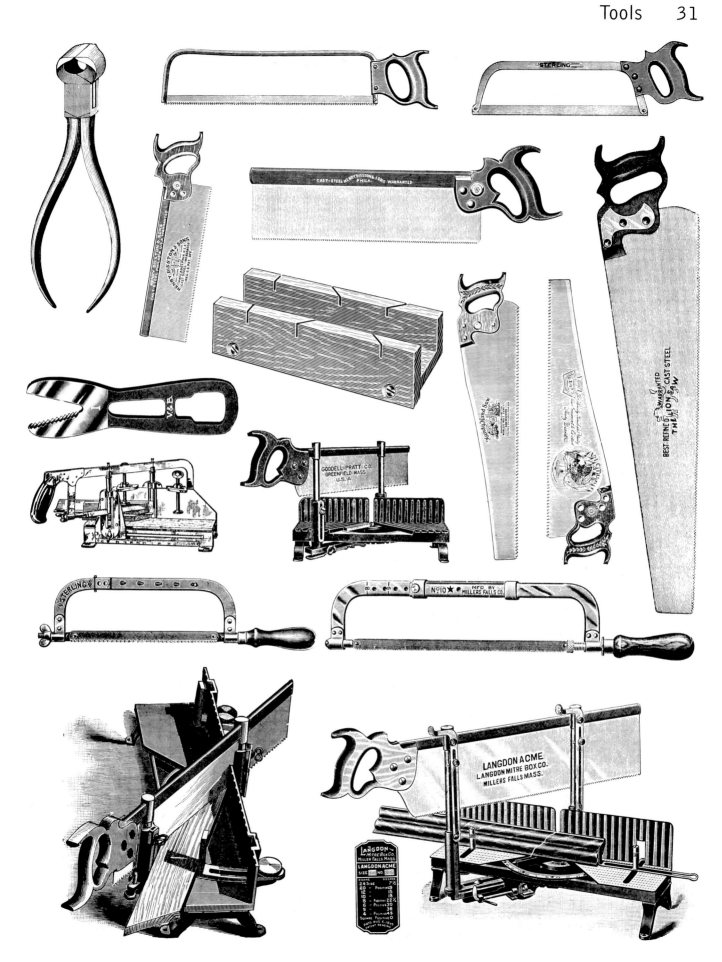

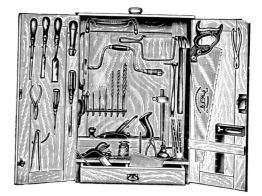

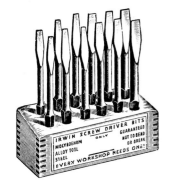

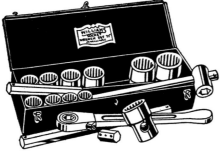

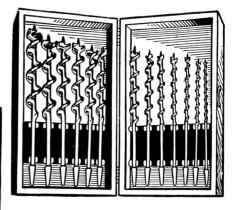

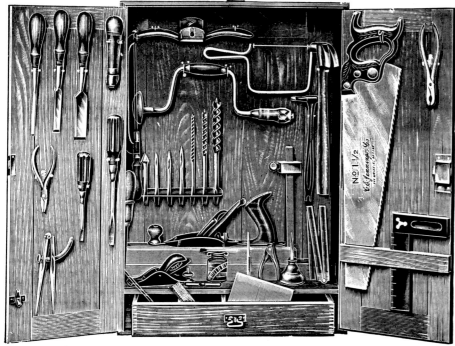

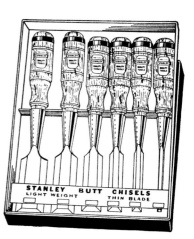

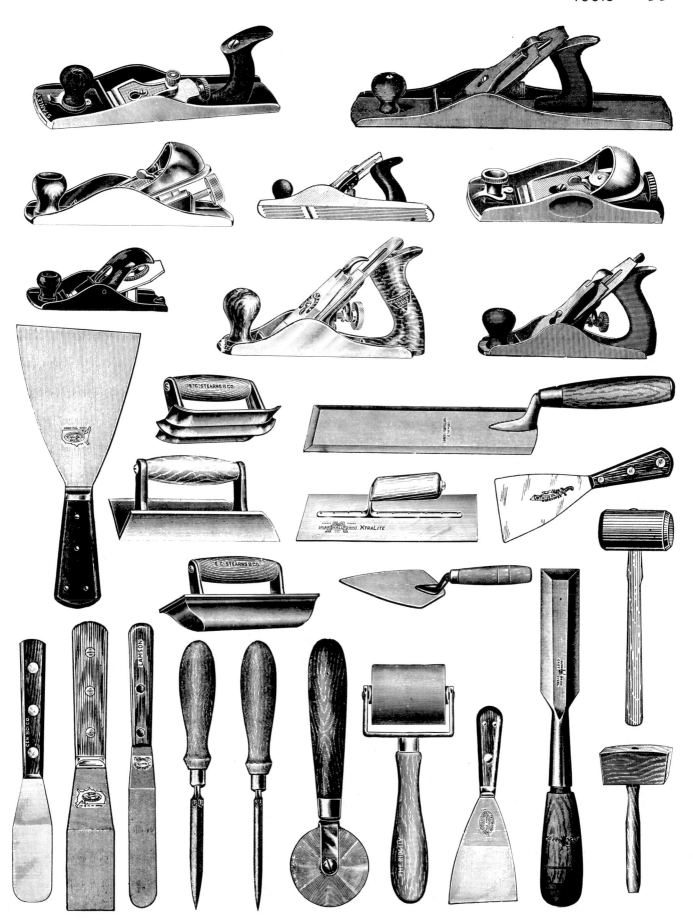

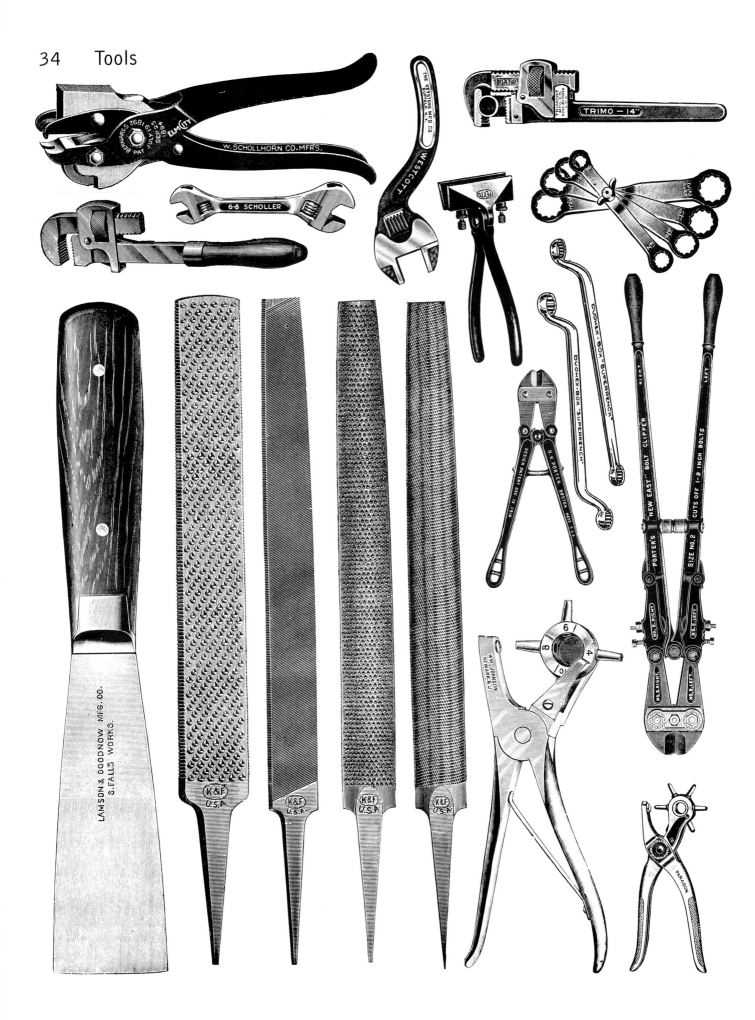

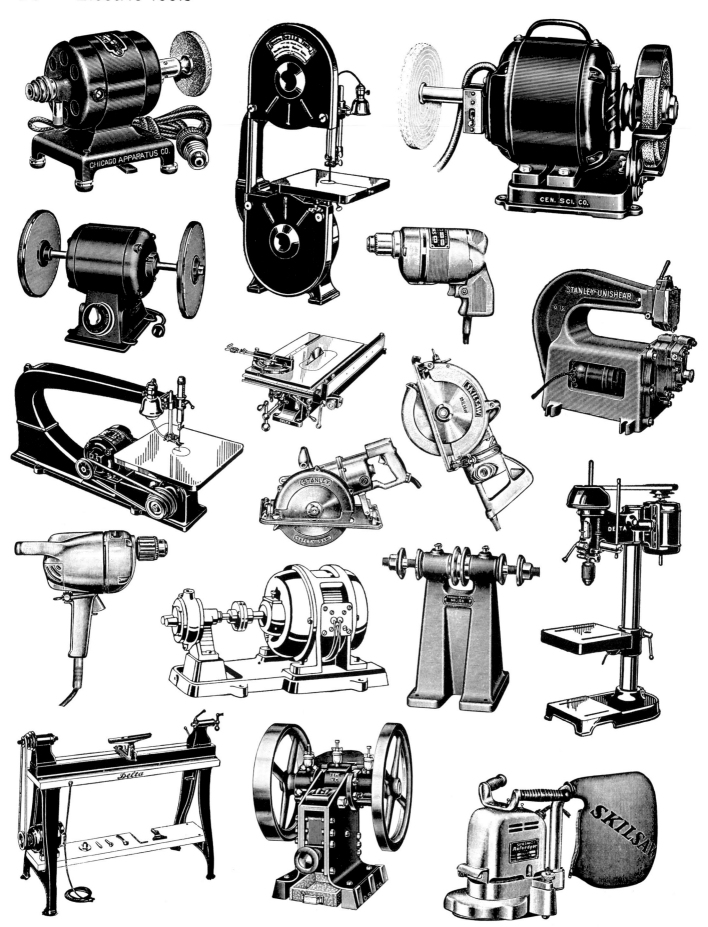

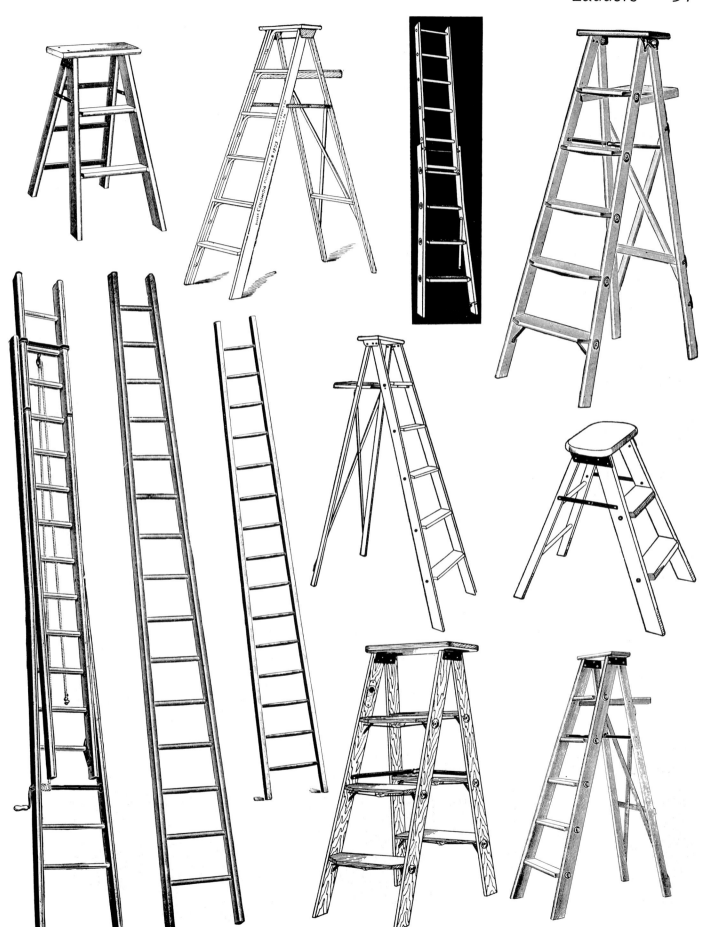

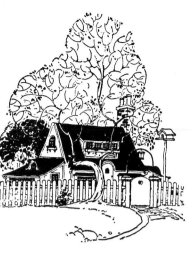
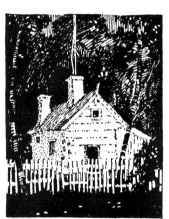
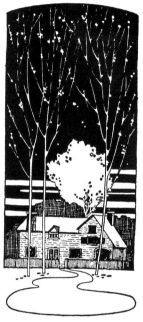

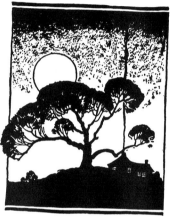

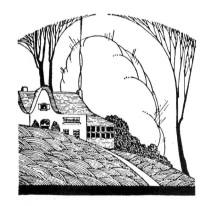

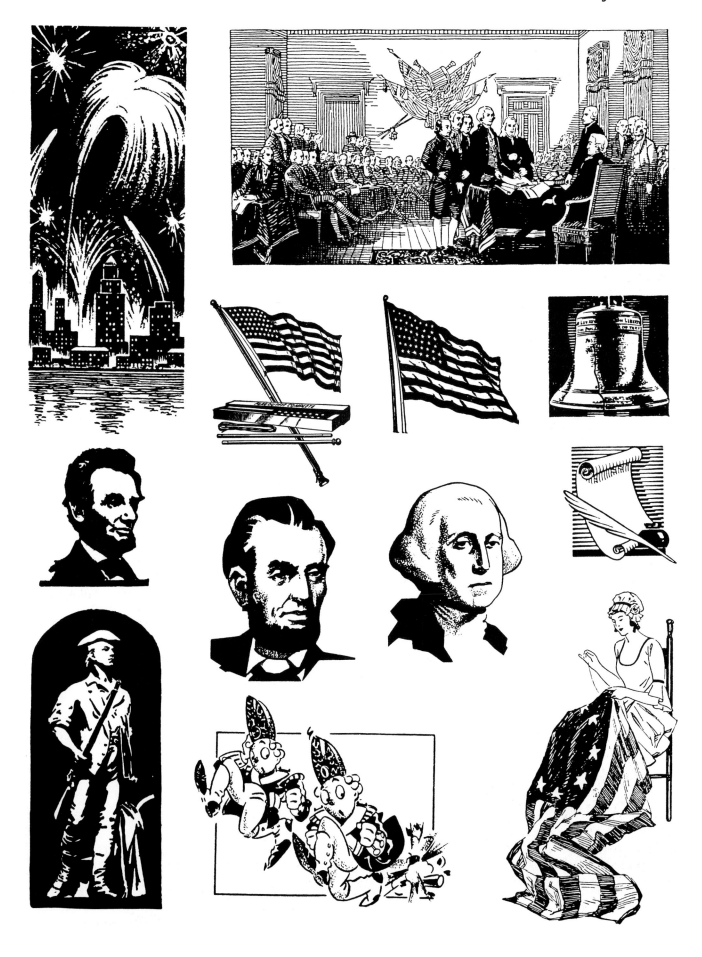

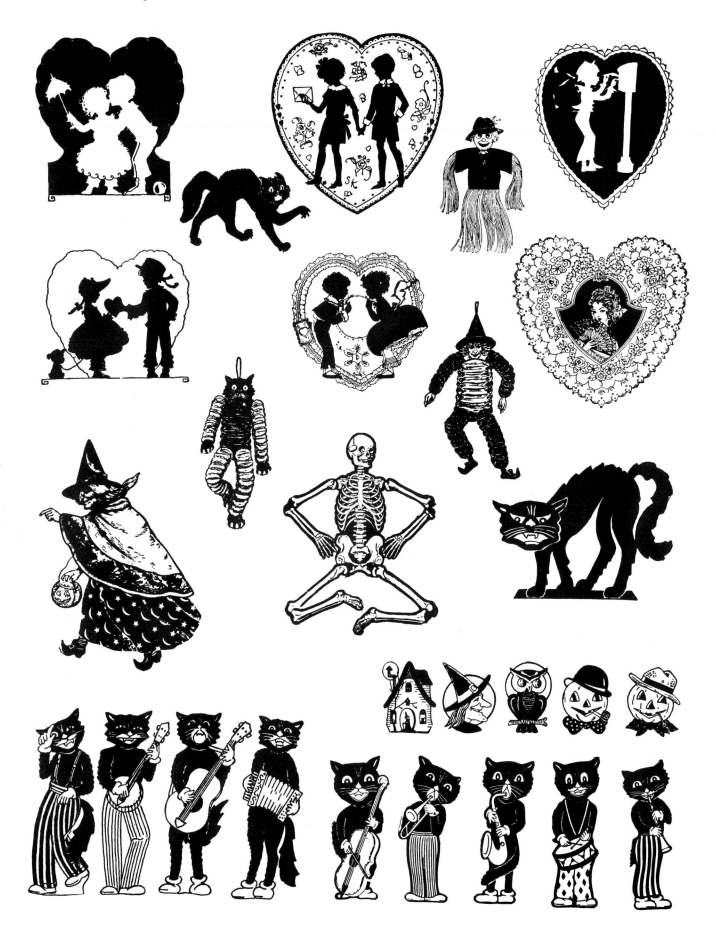

A MERRIE CHRISTMAS!

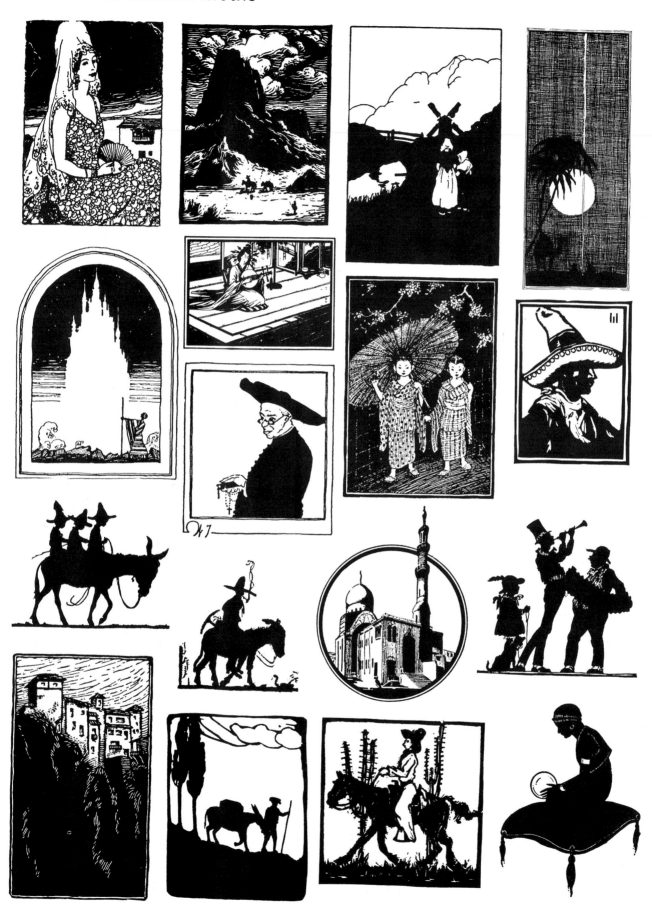

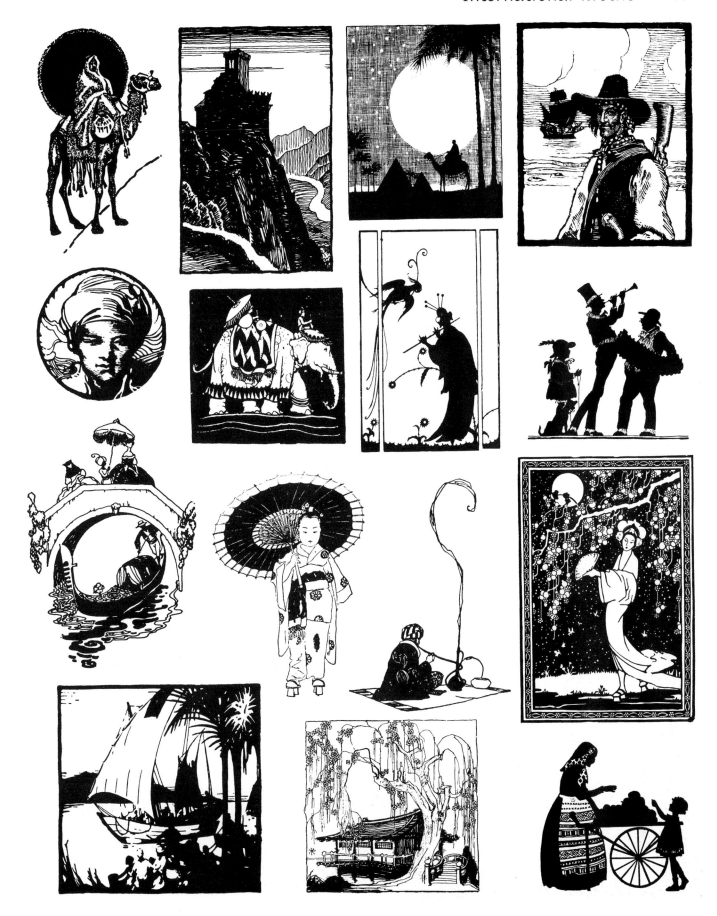

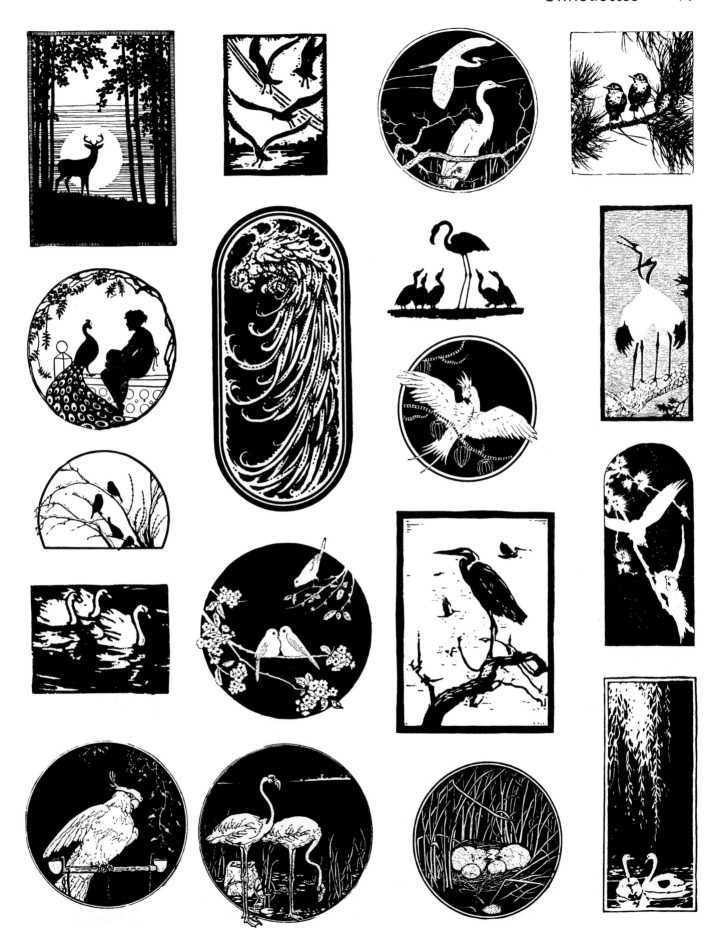

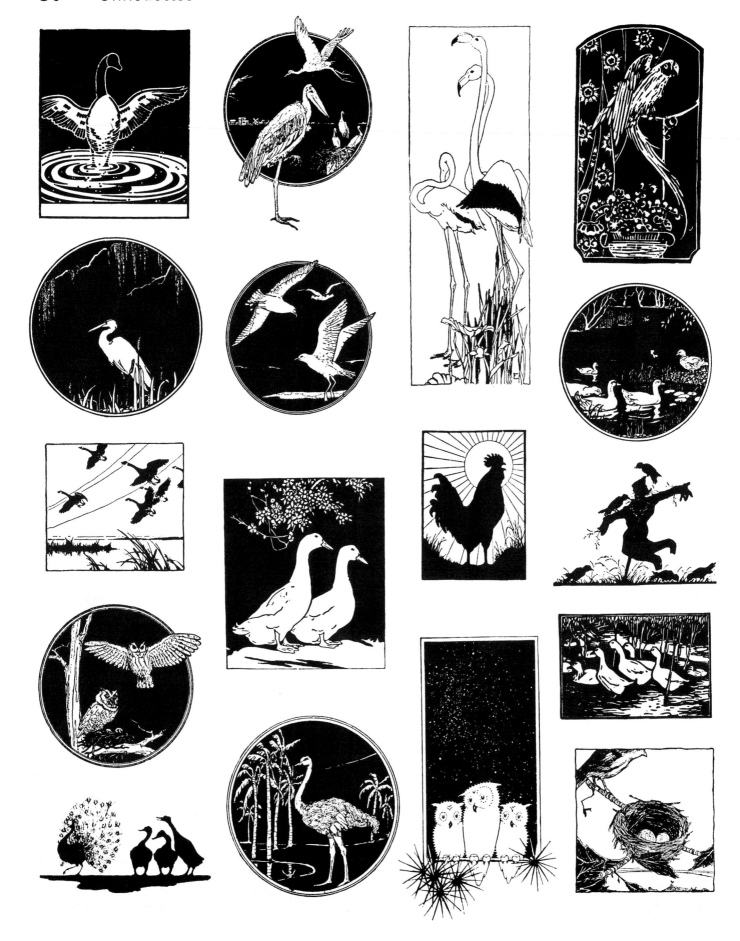

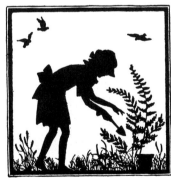
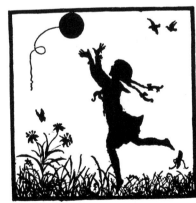
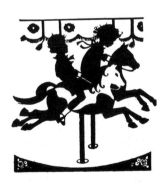

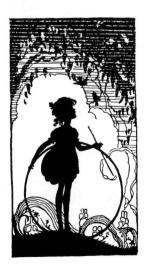

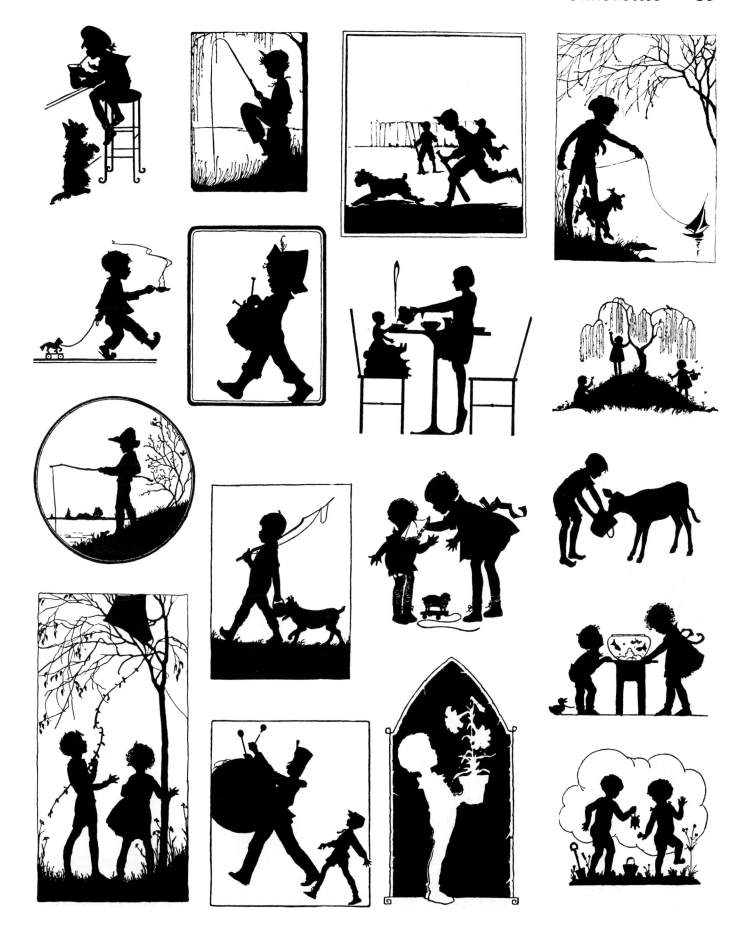

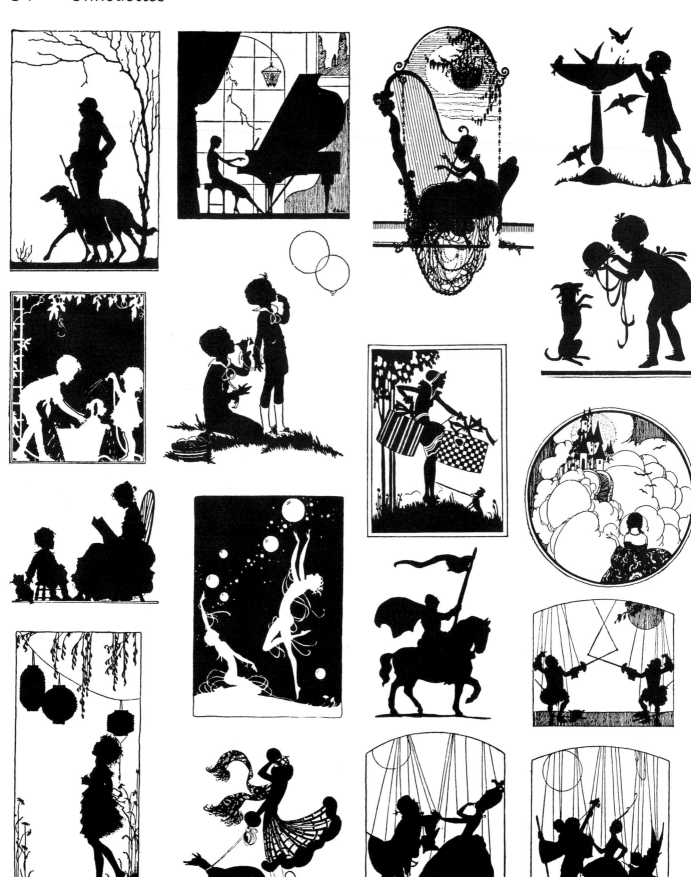

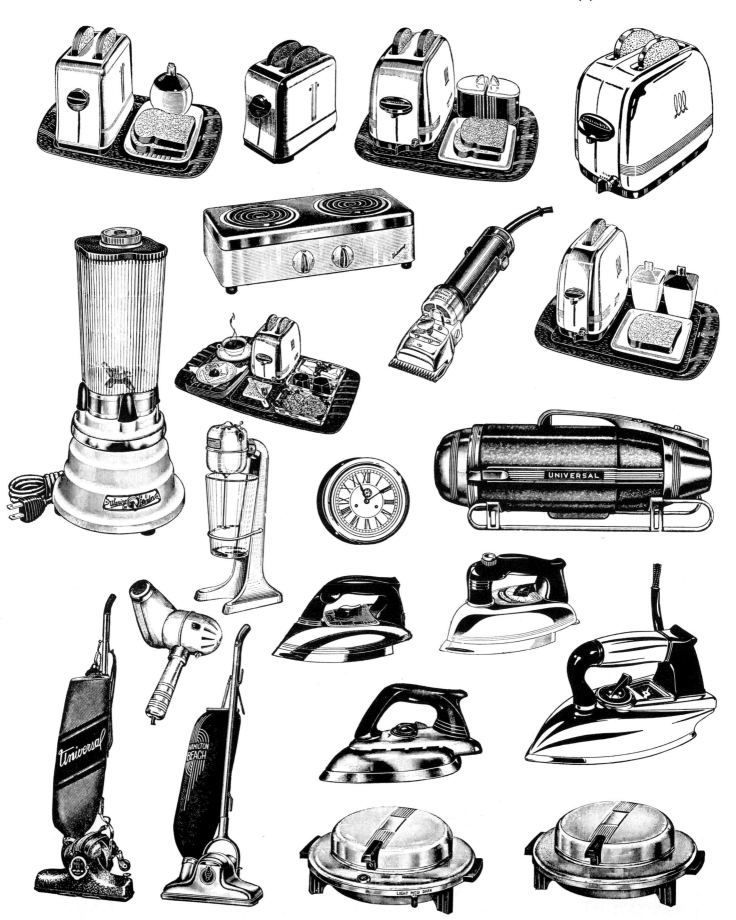

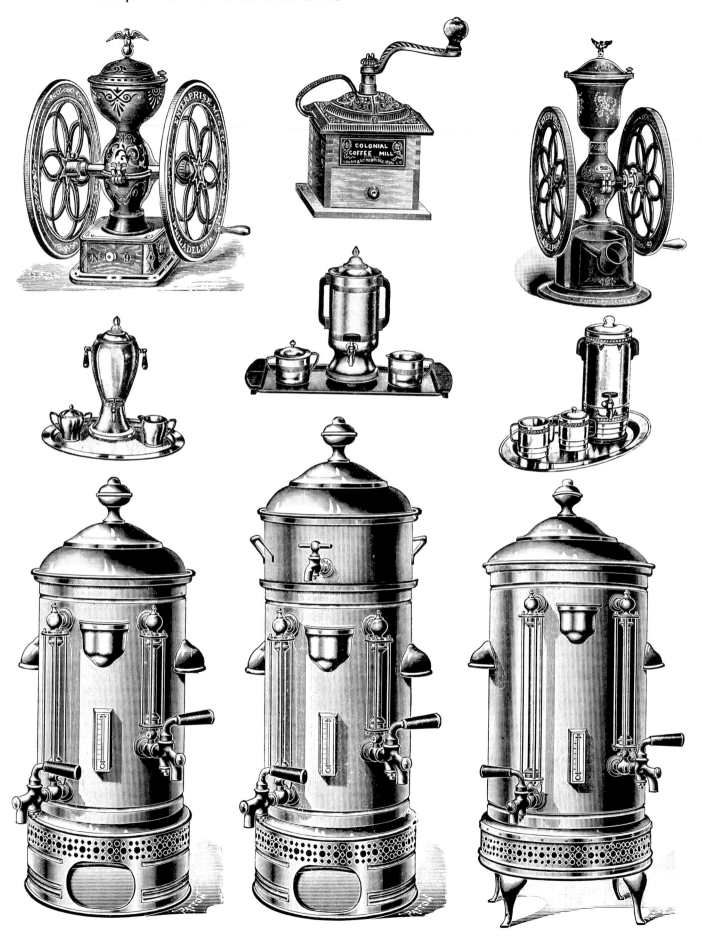

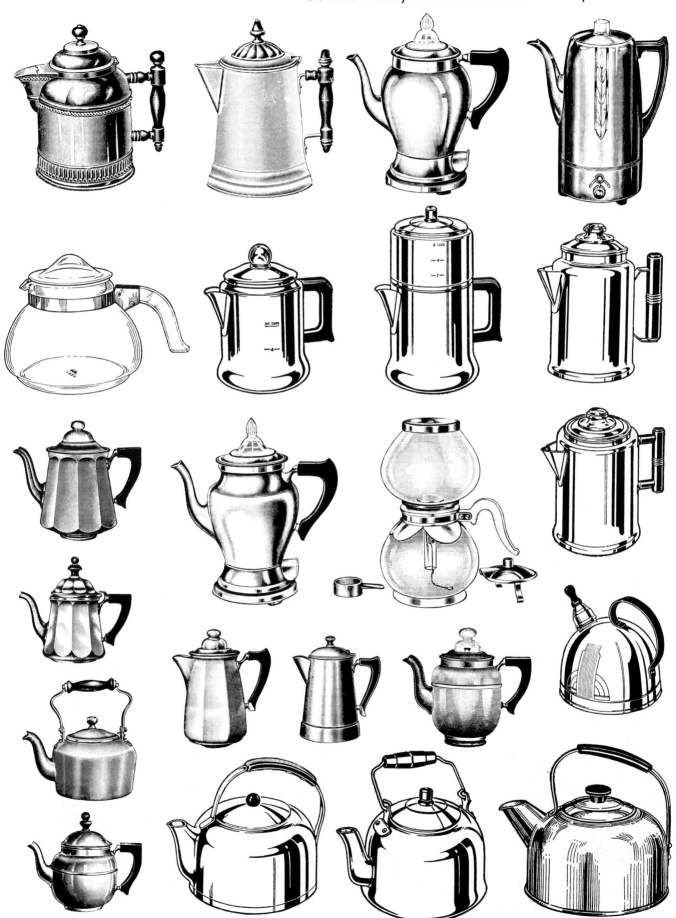

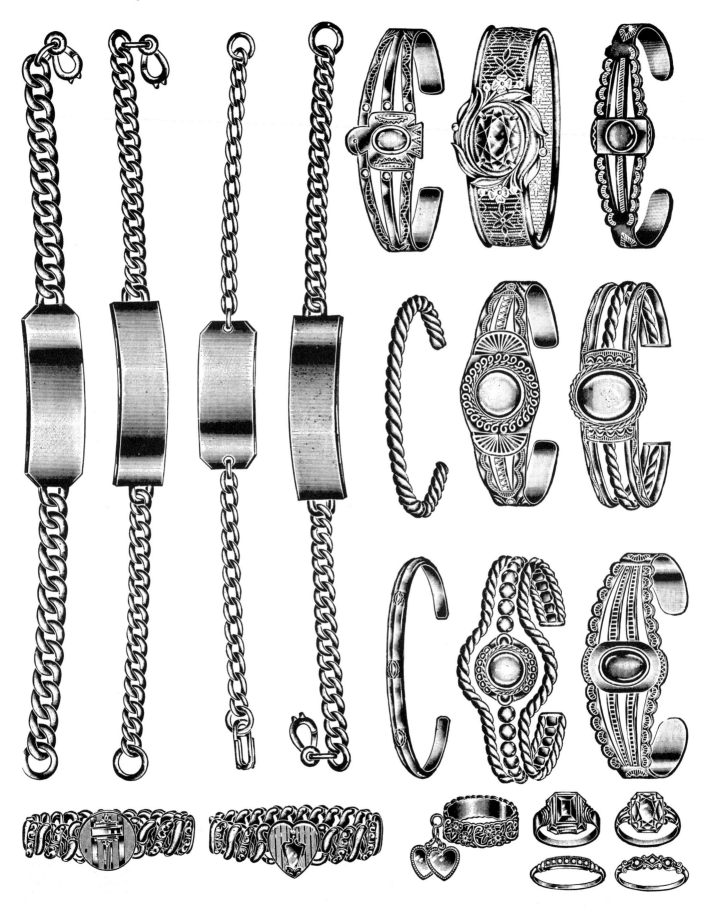

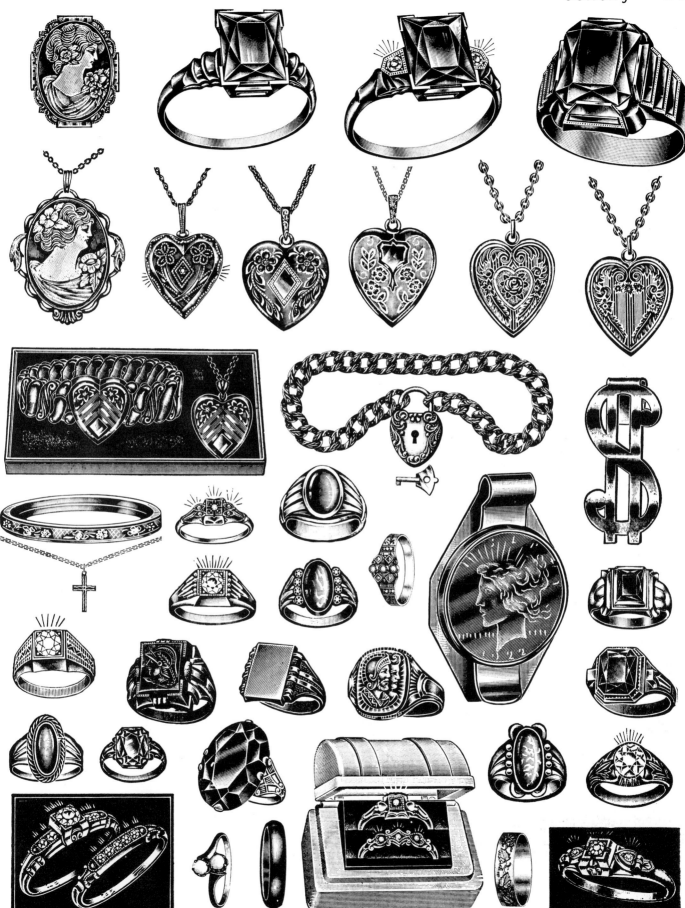

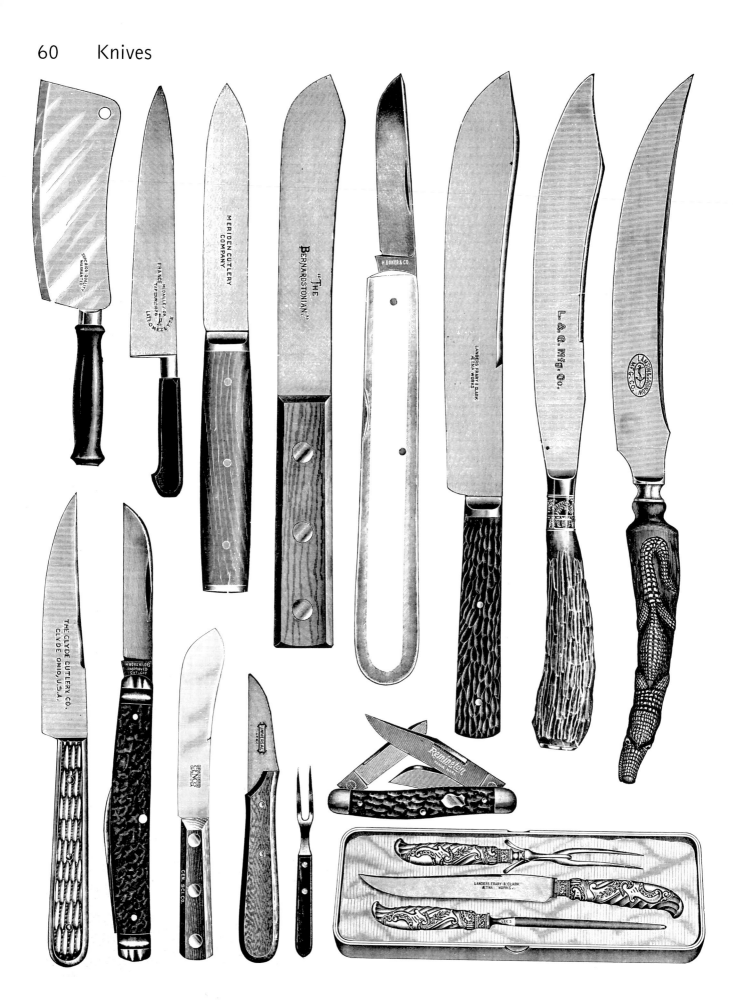

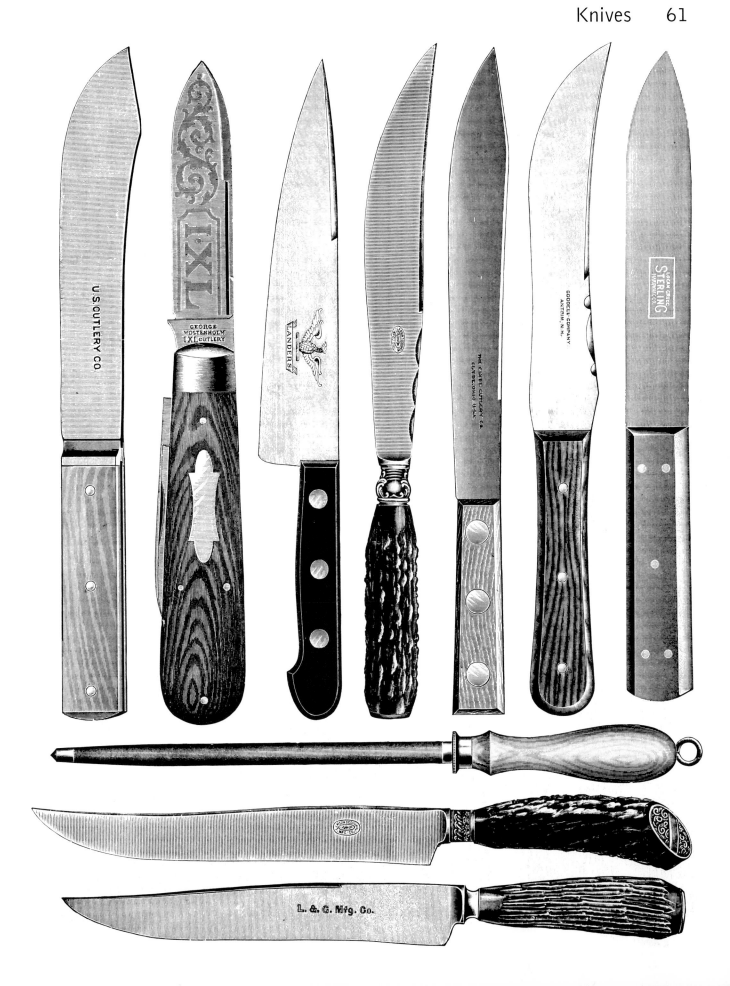

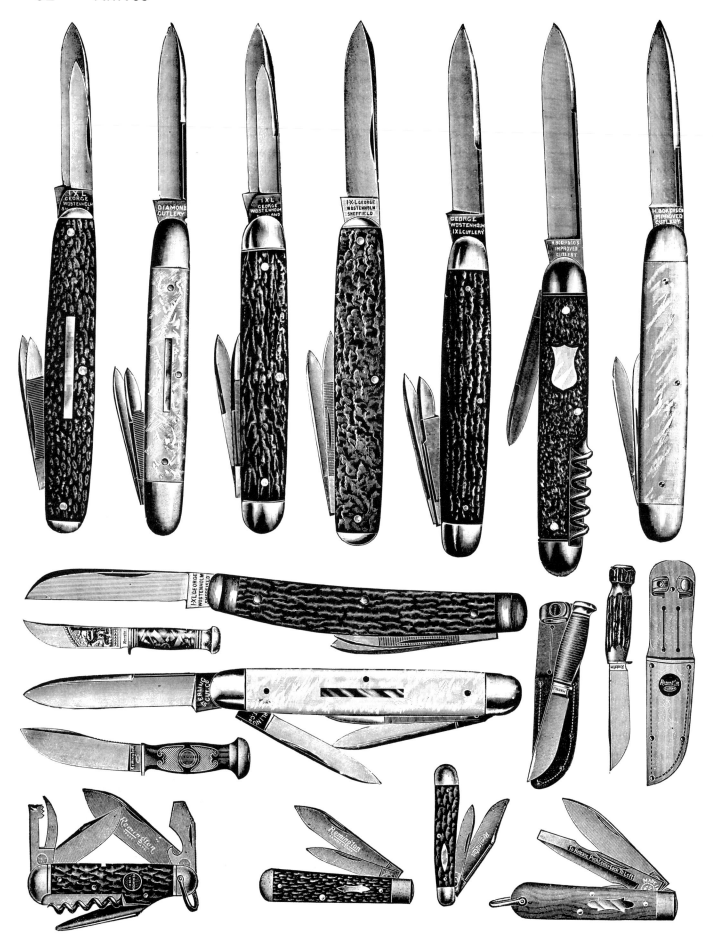

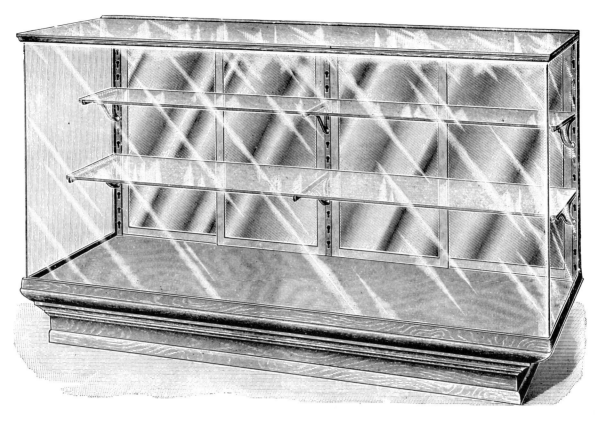

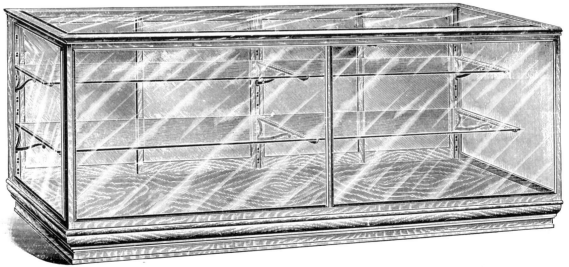

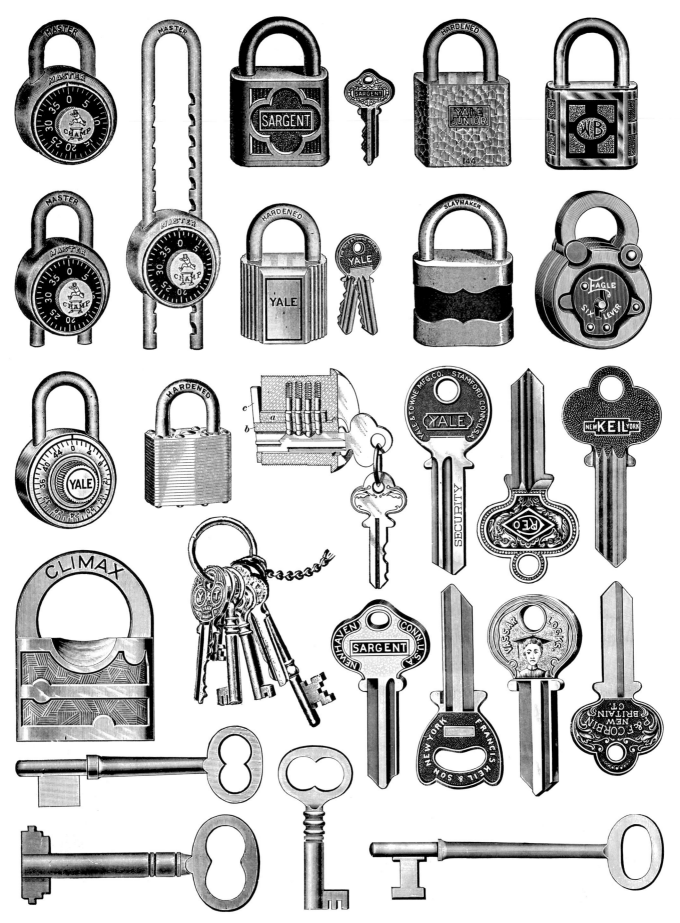

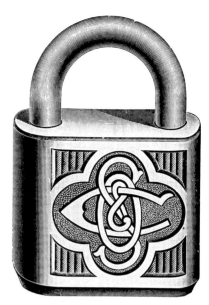

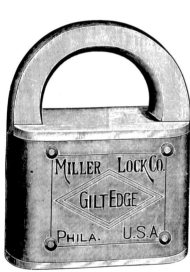

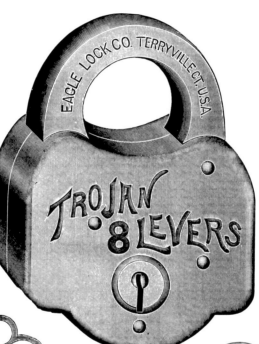

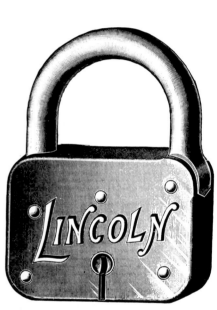

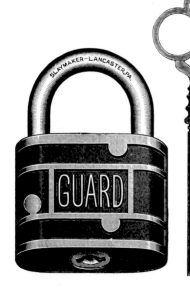

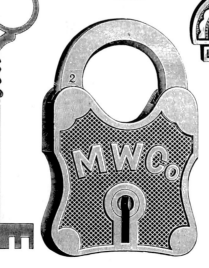

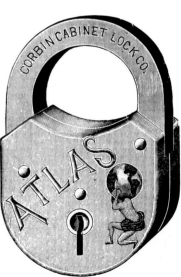

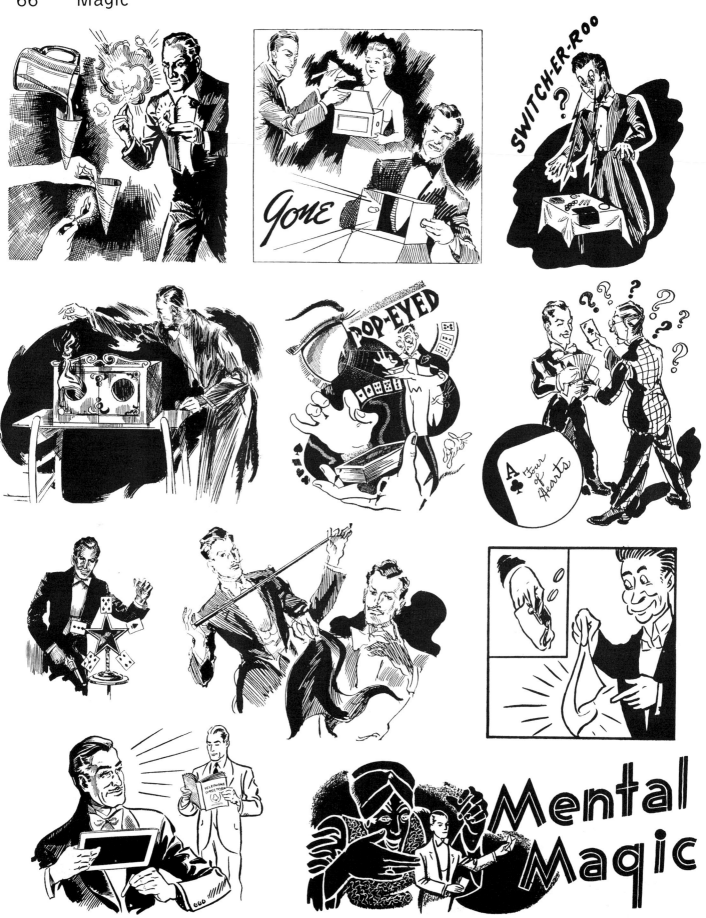

Just THINK of a CARD

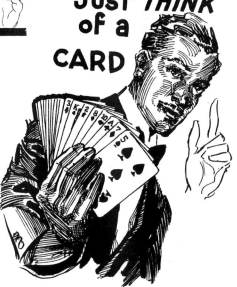

GONE!

GONE!

Green Red

Card magic

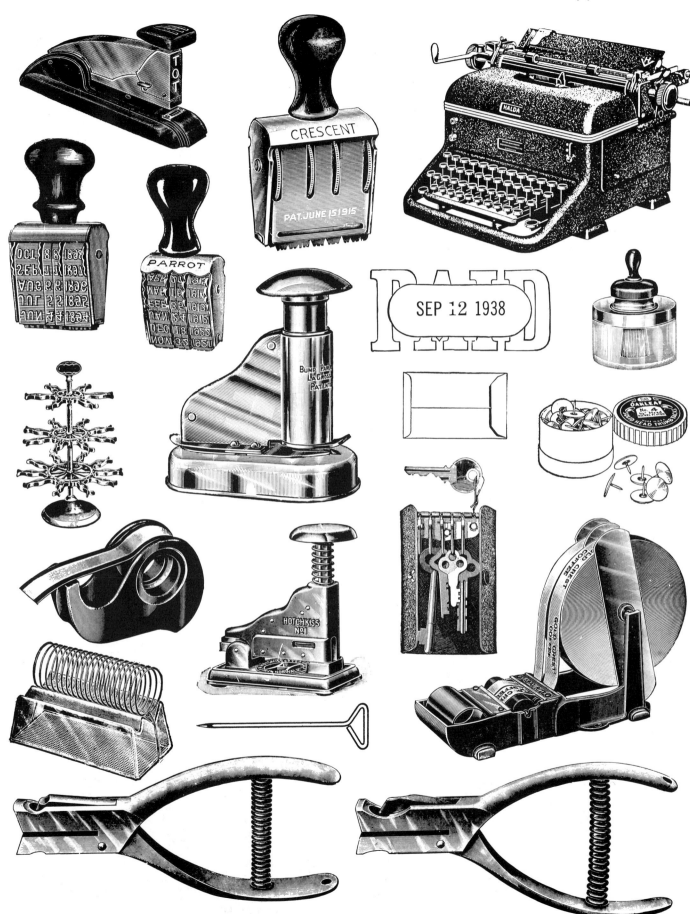

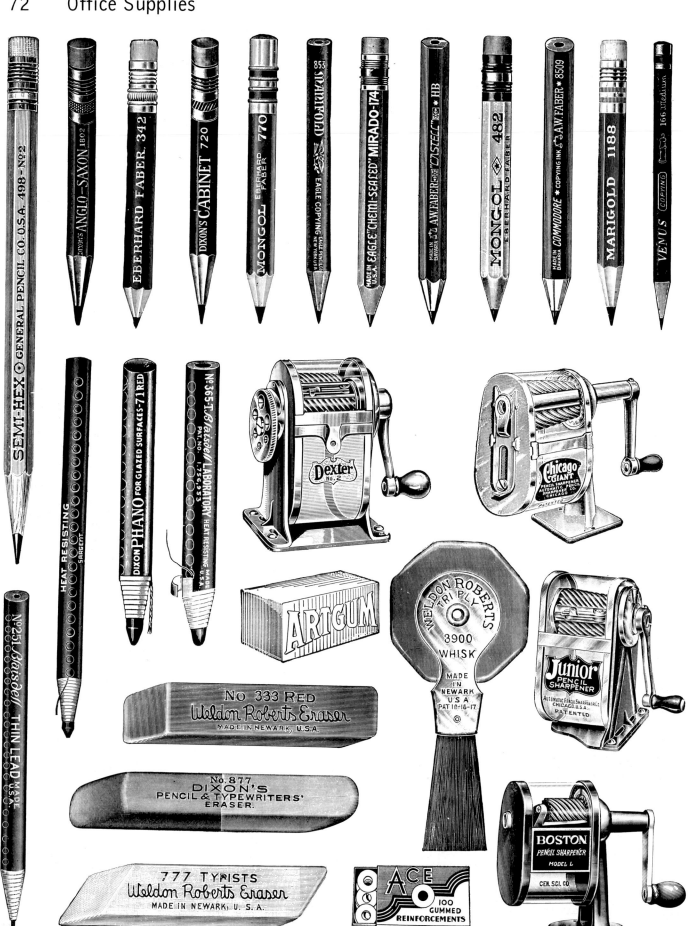

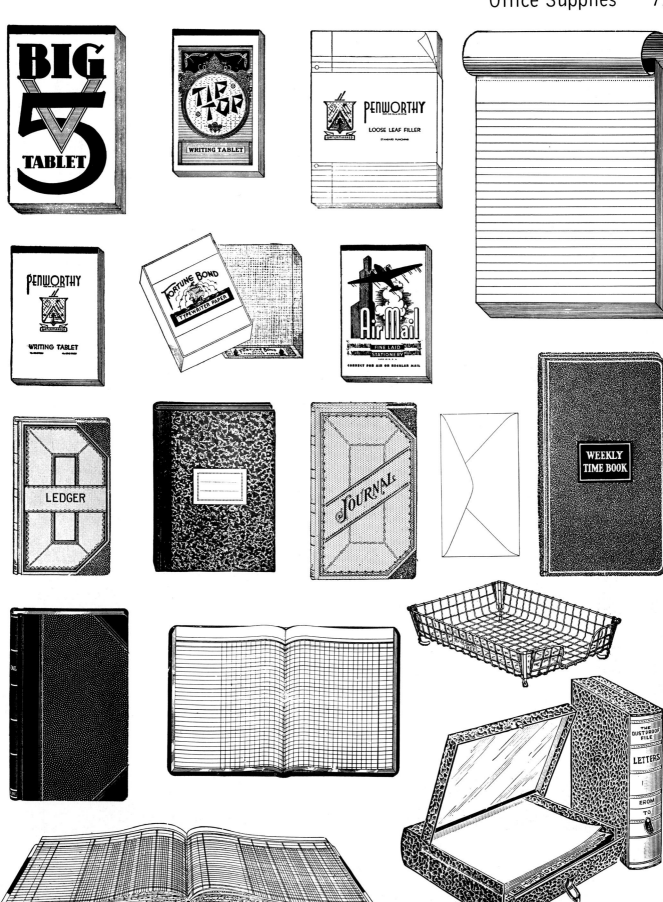

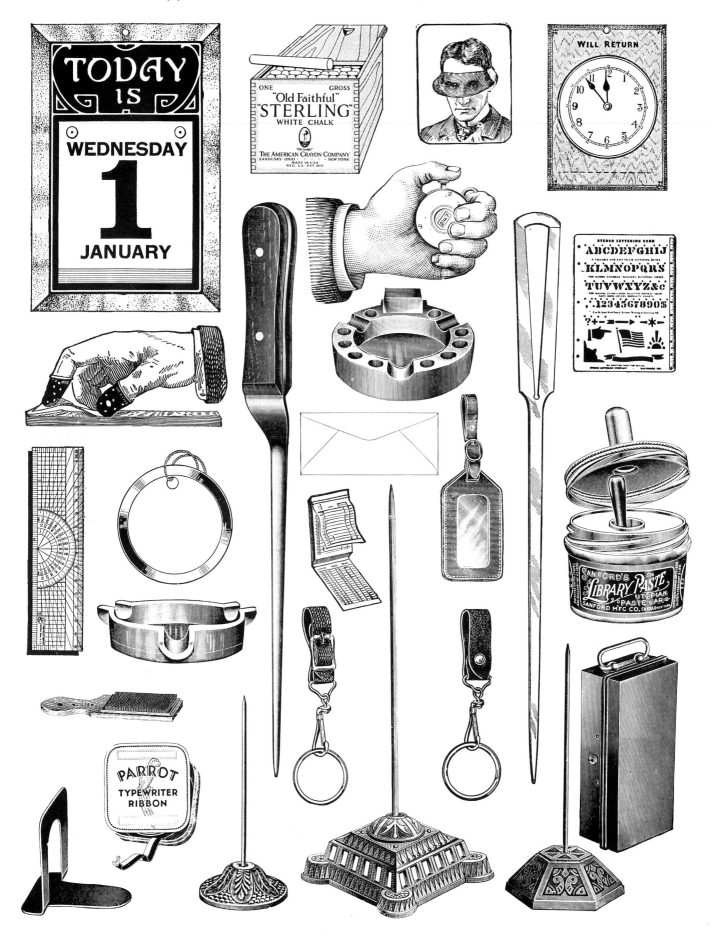

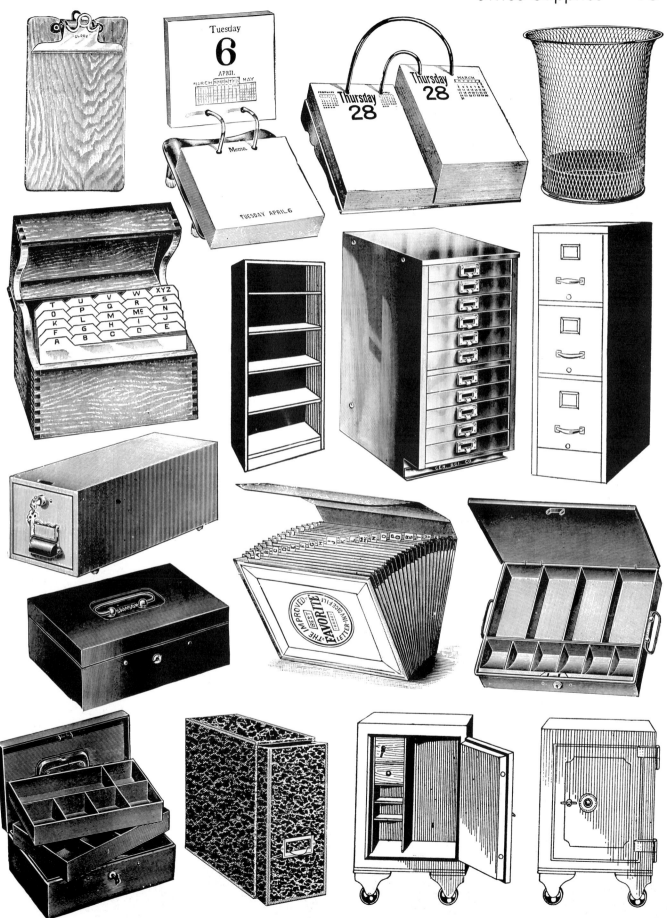

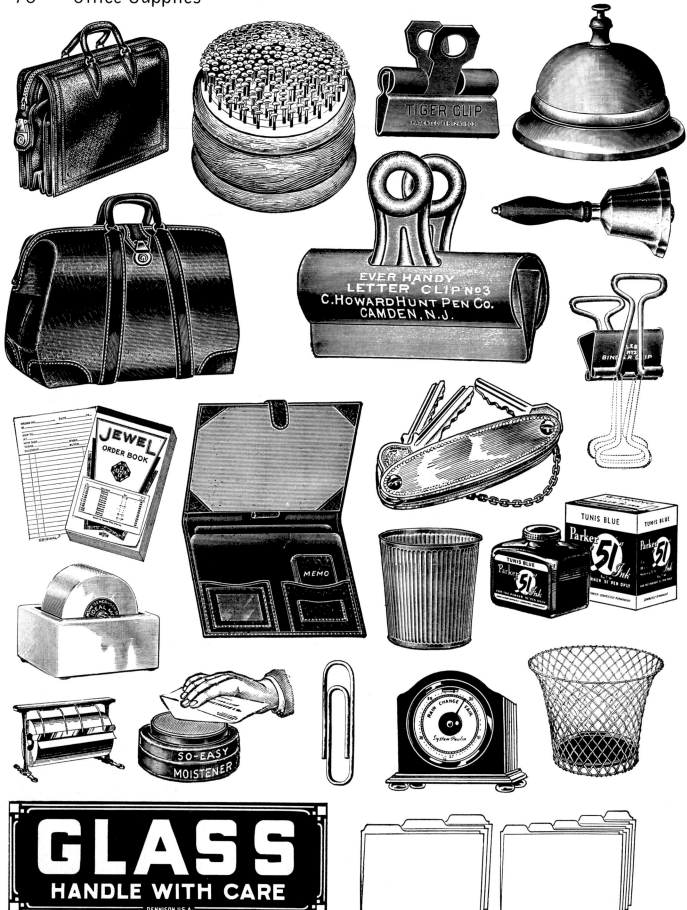

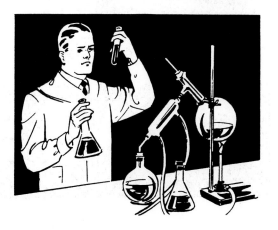

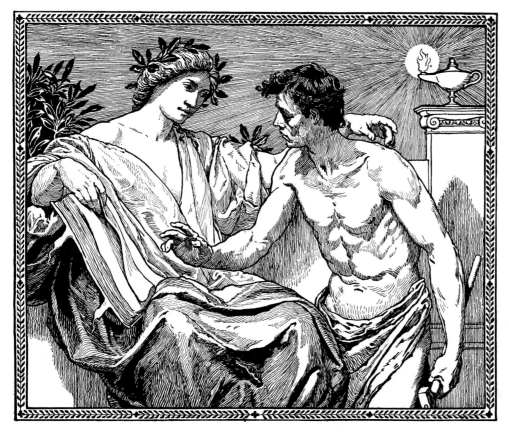

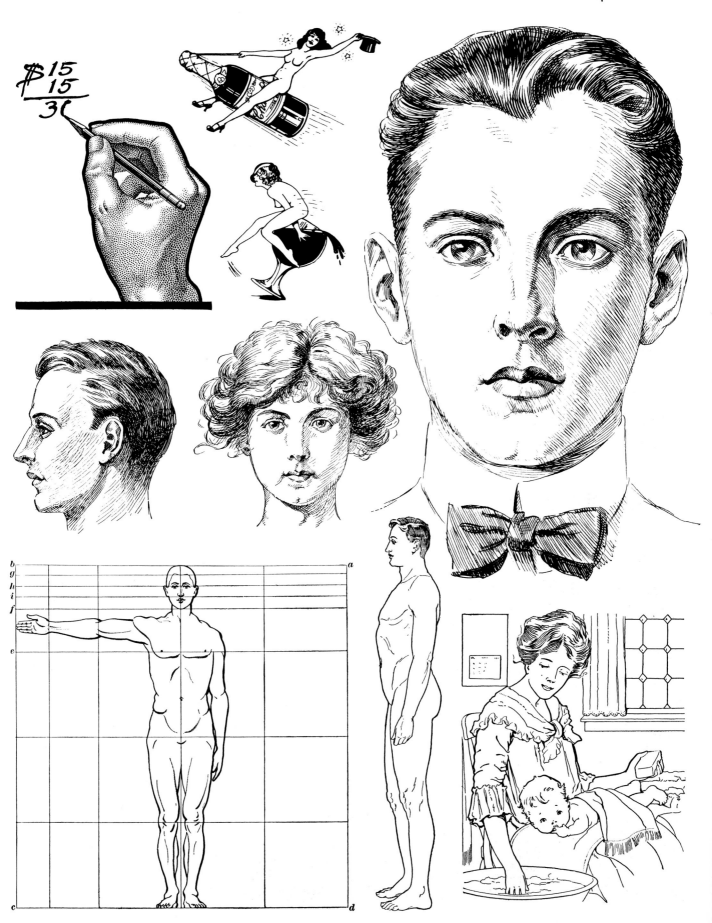

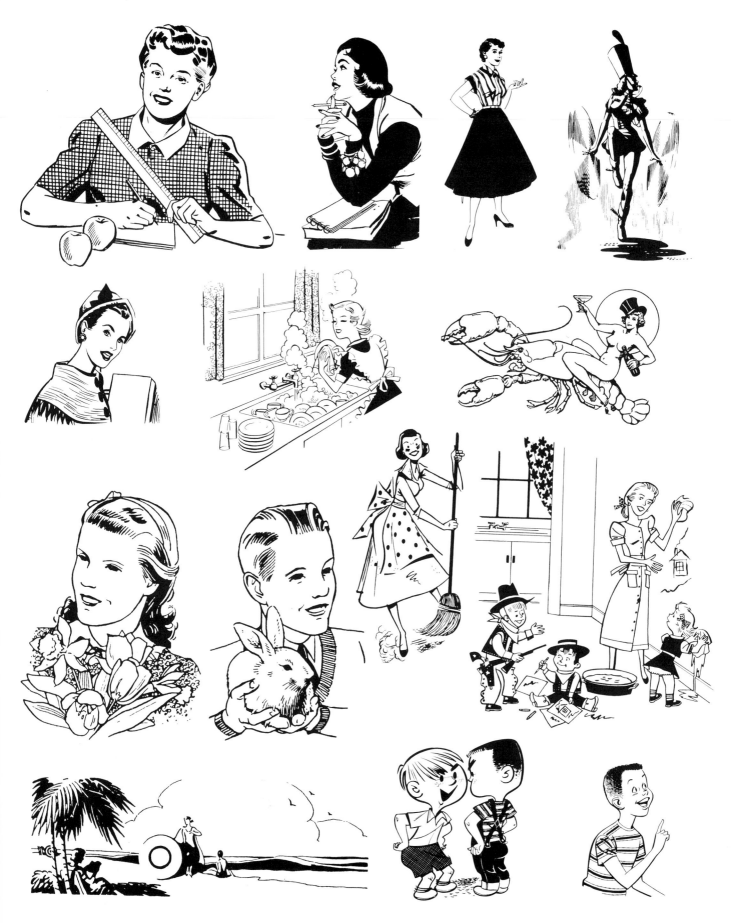

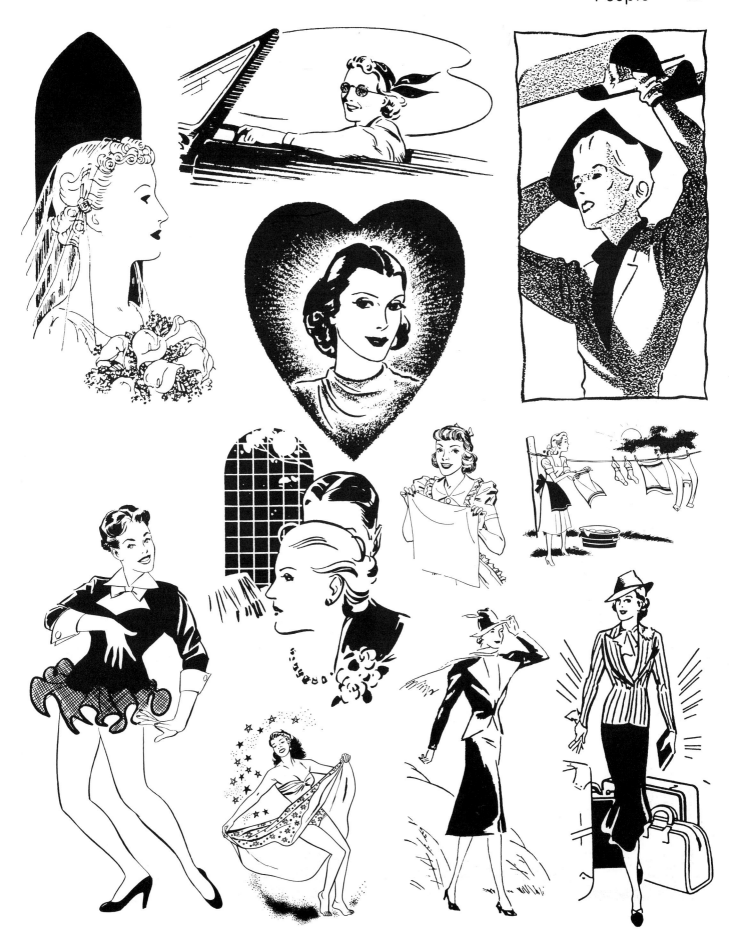

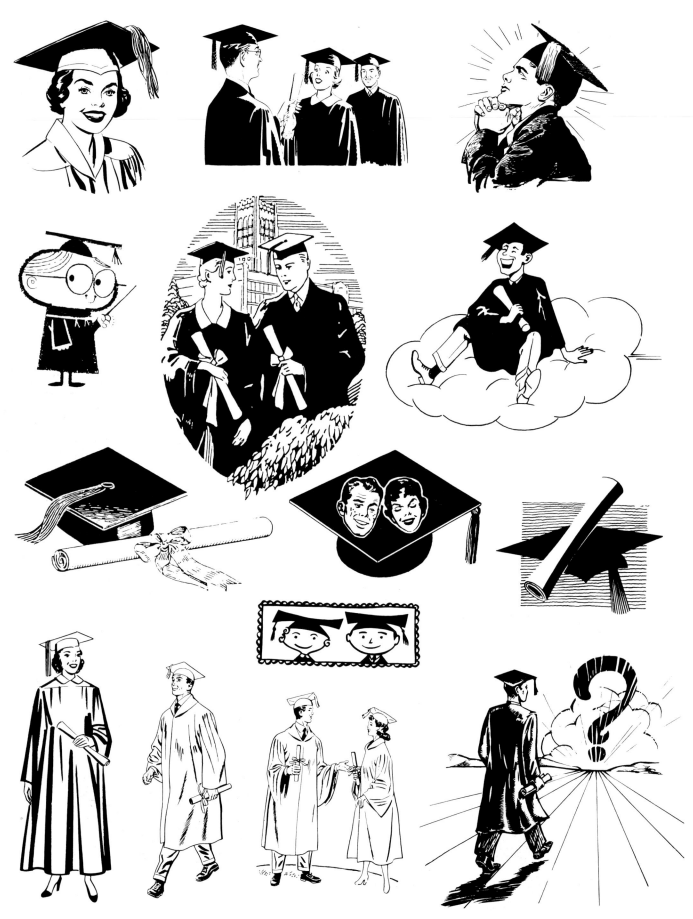

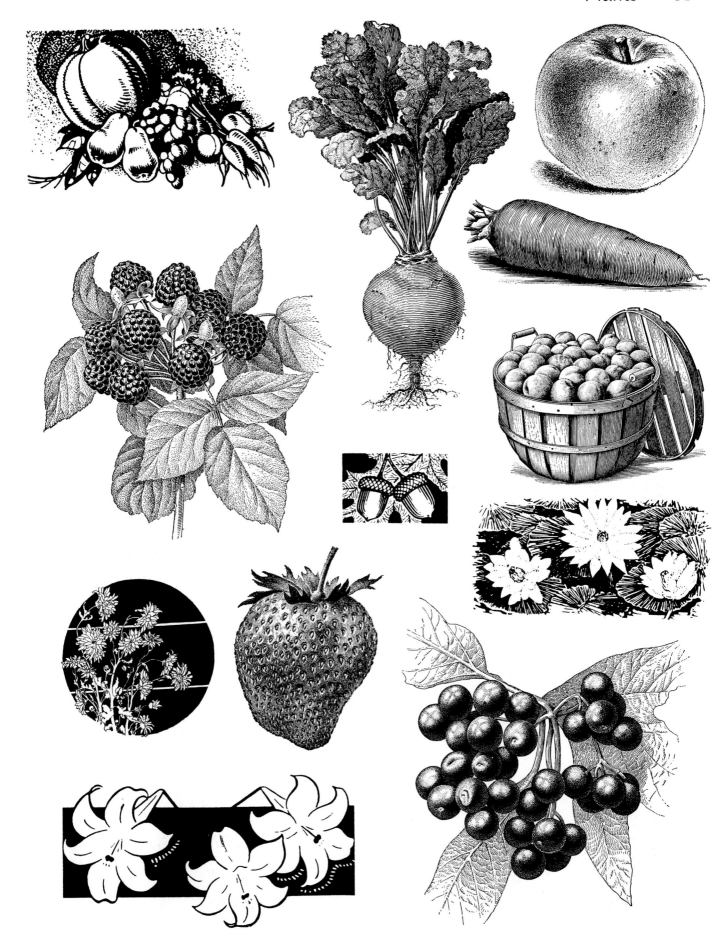

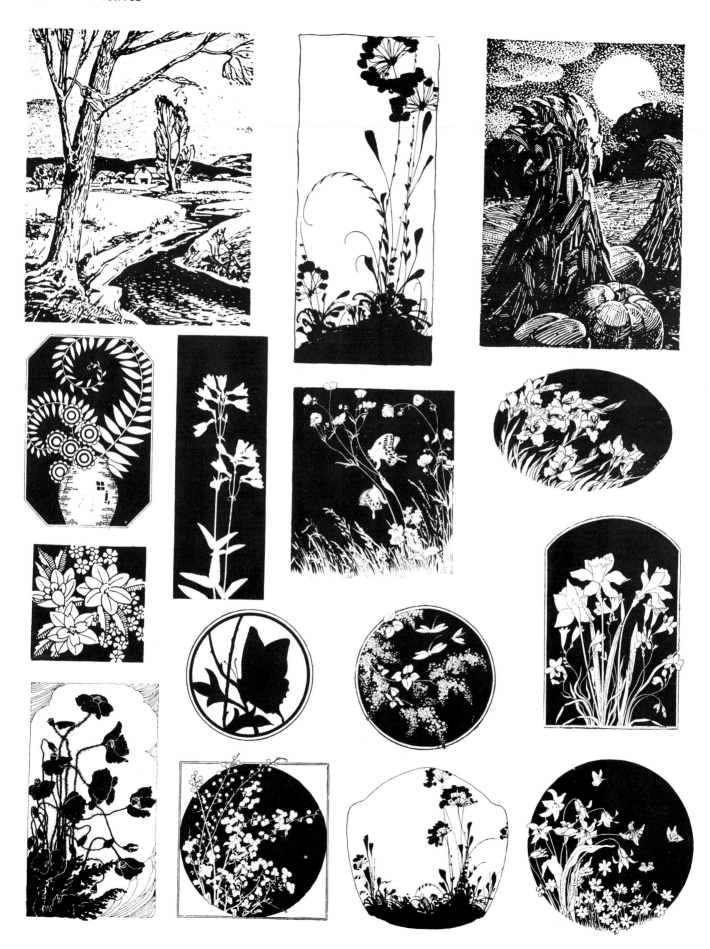

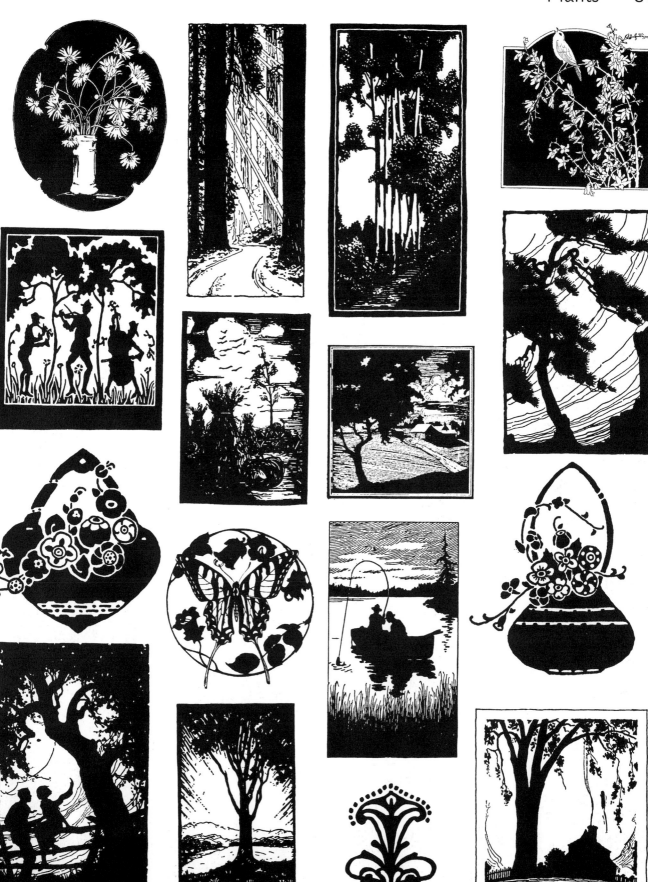

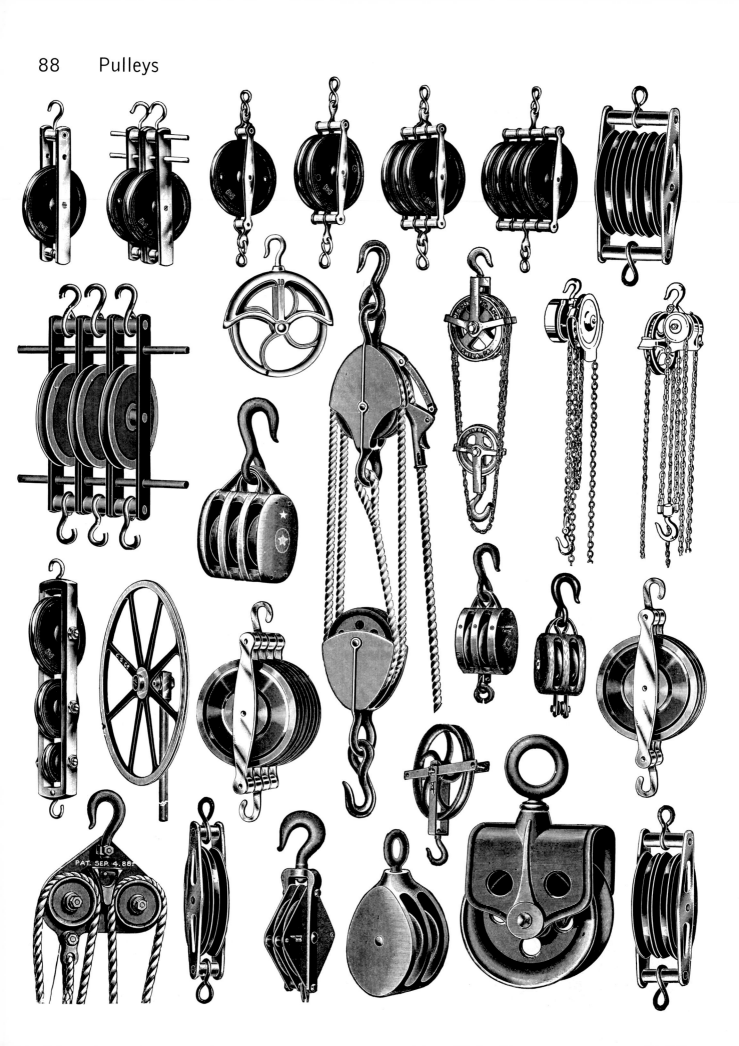

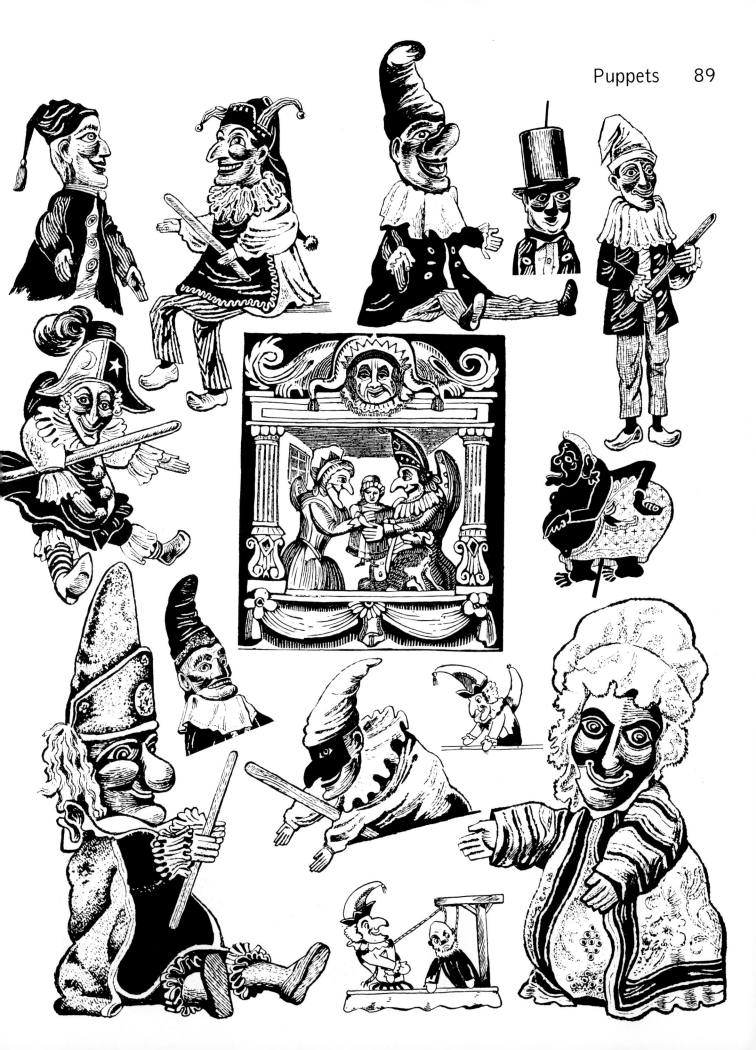

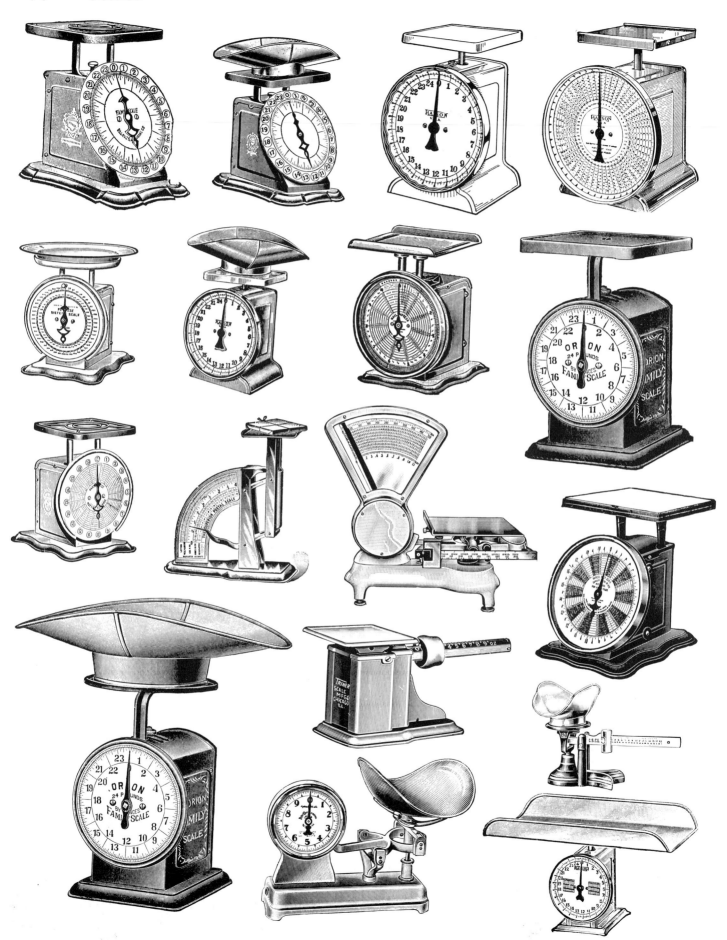

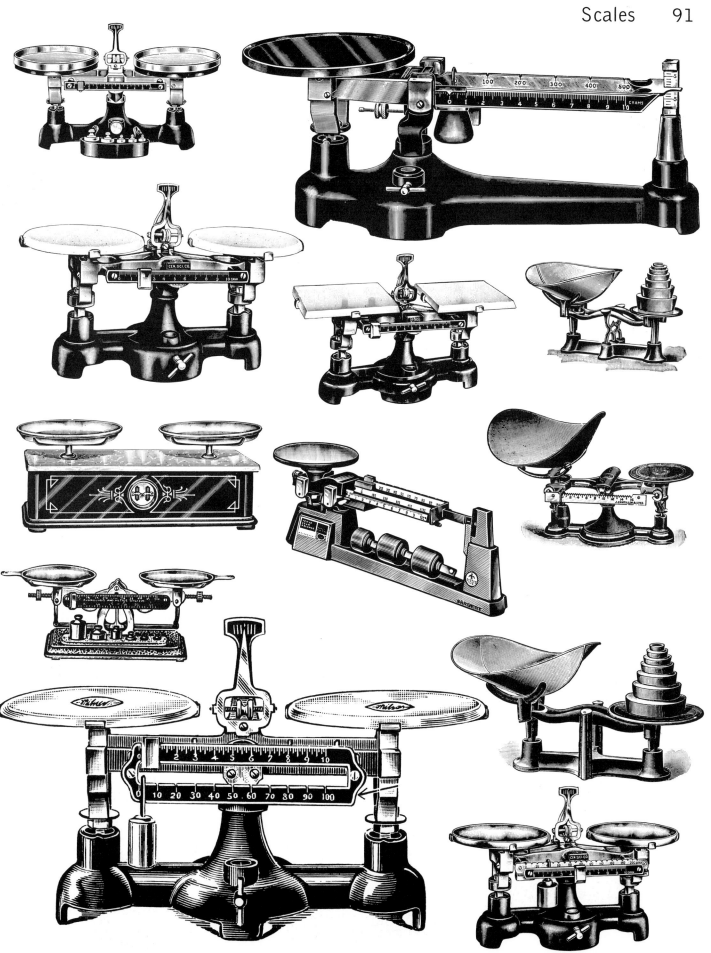

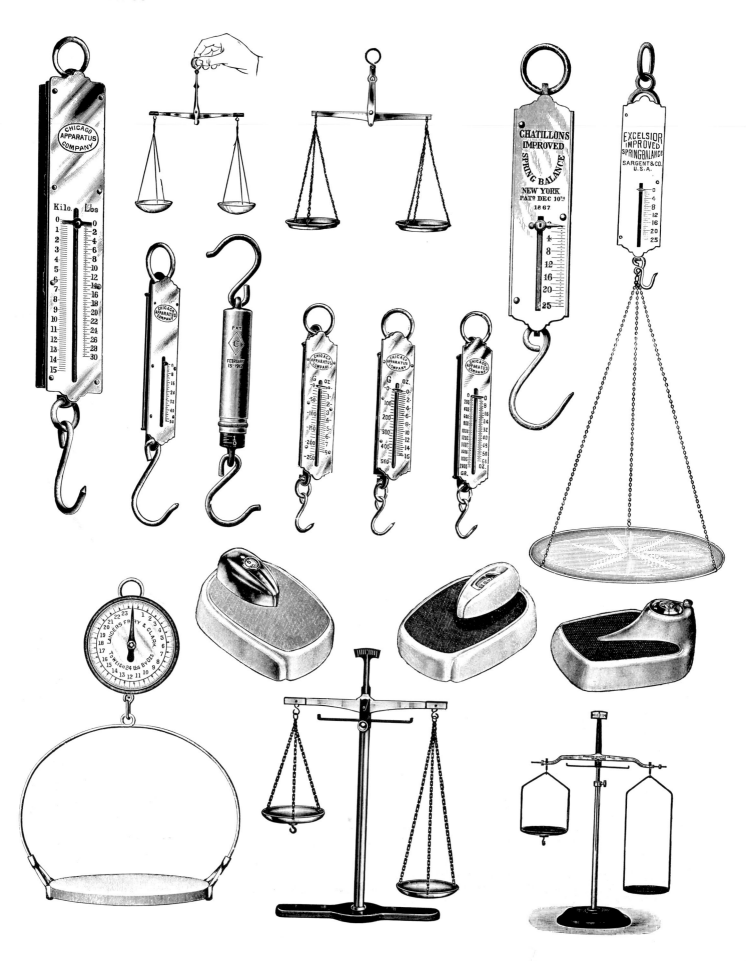

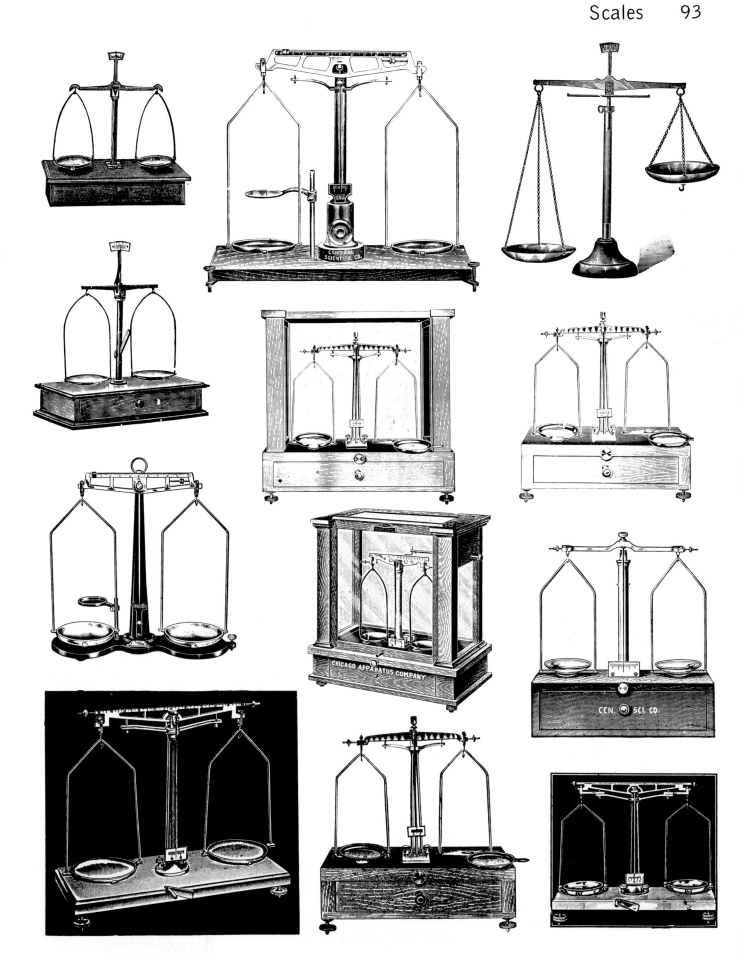

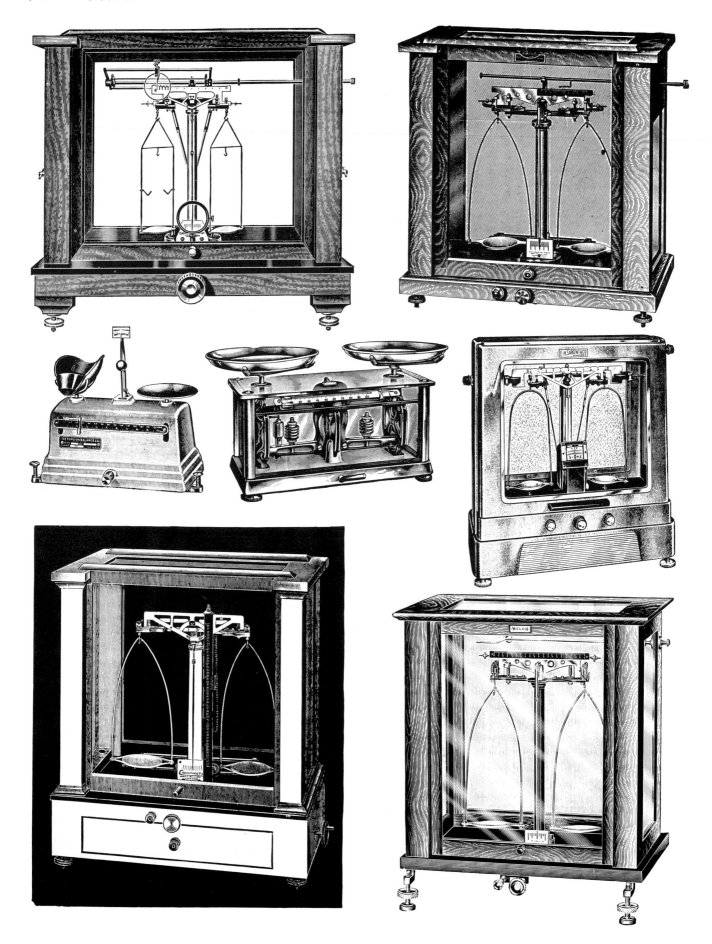

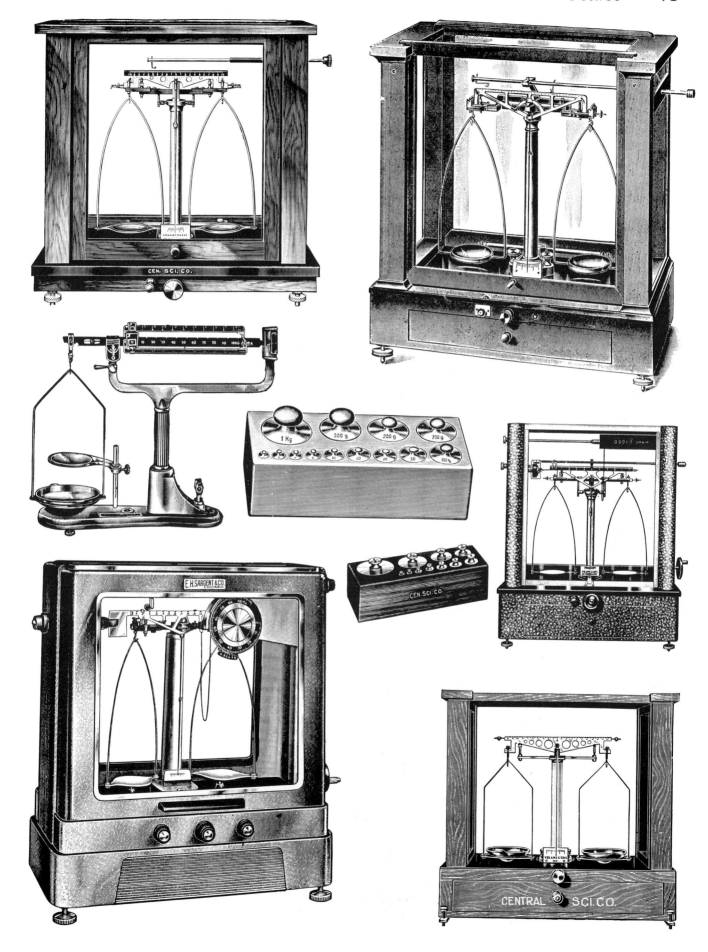

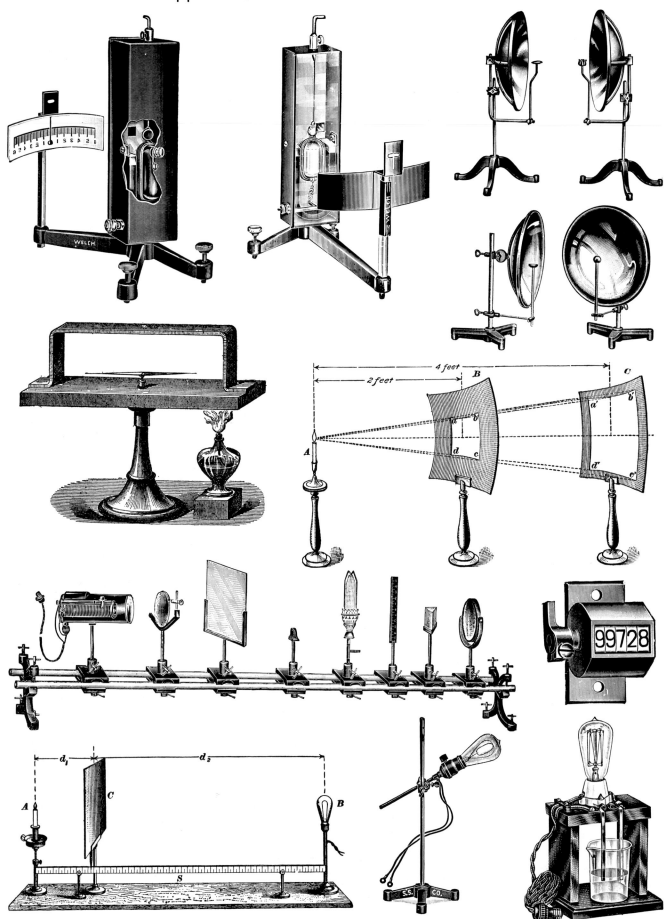

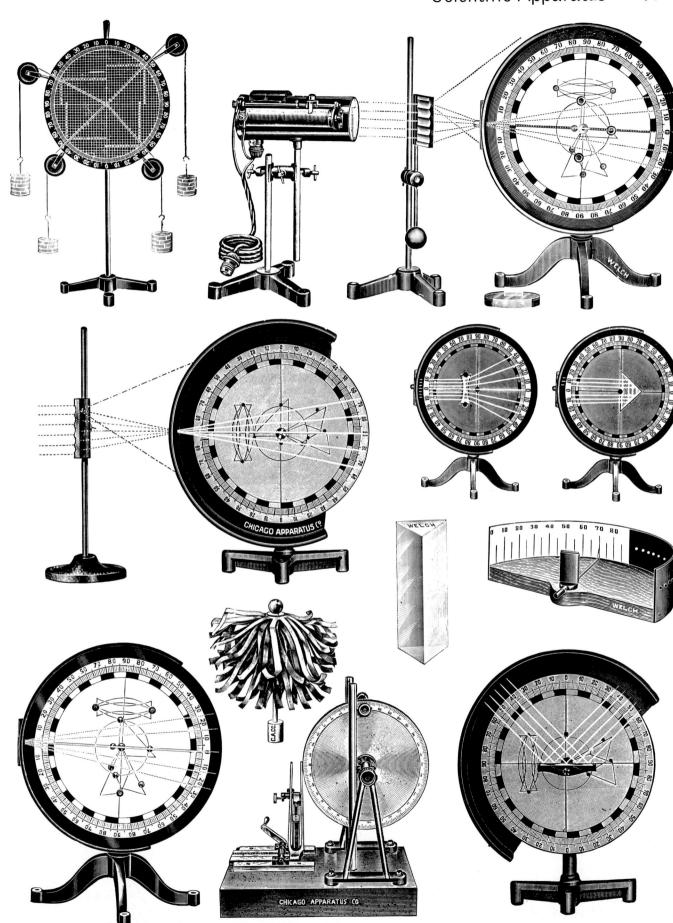

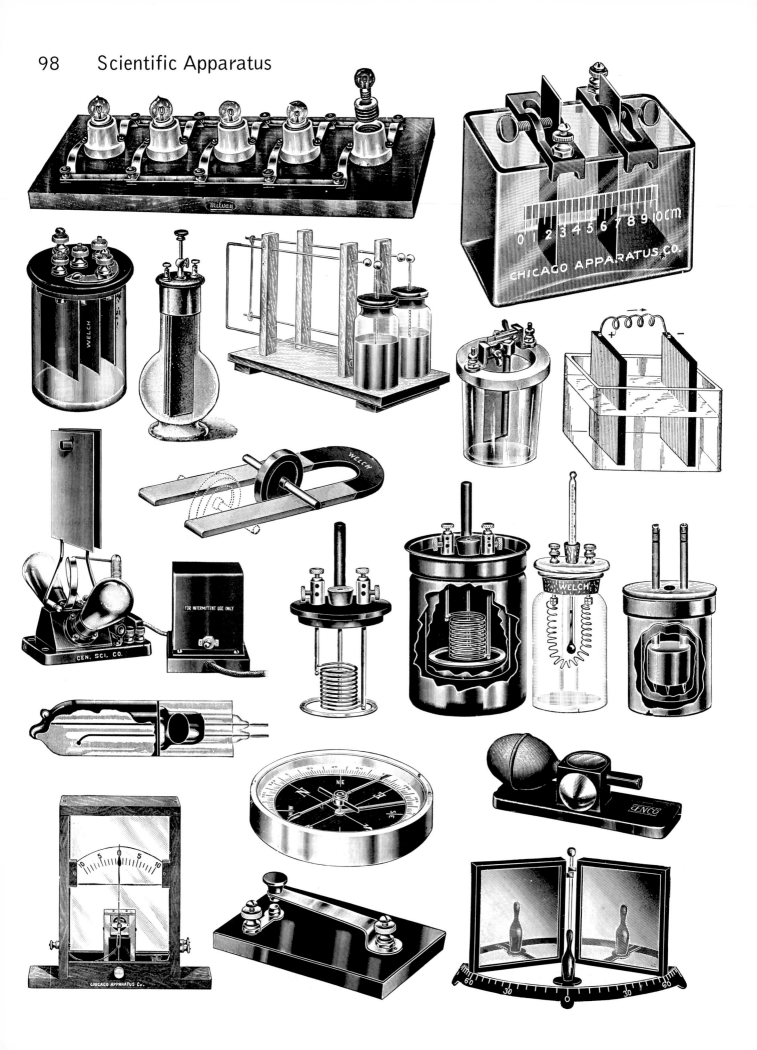

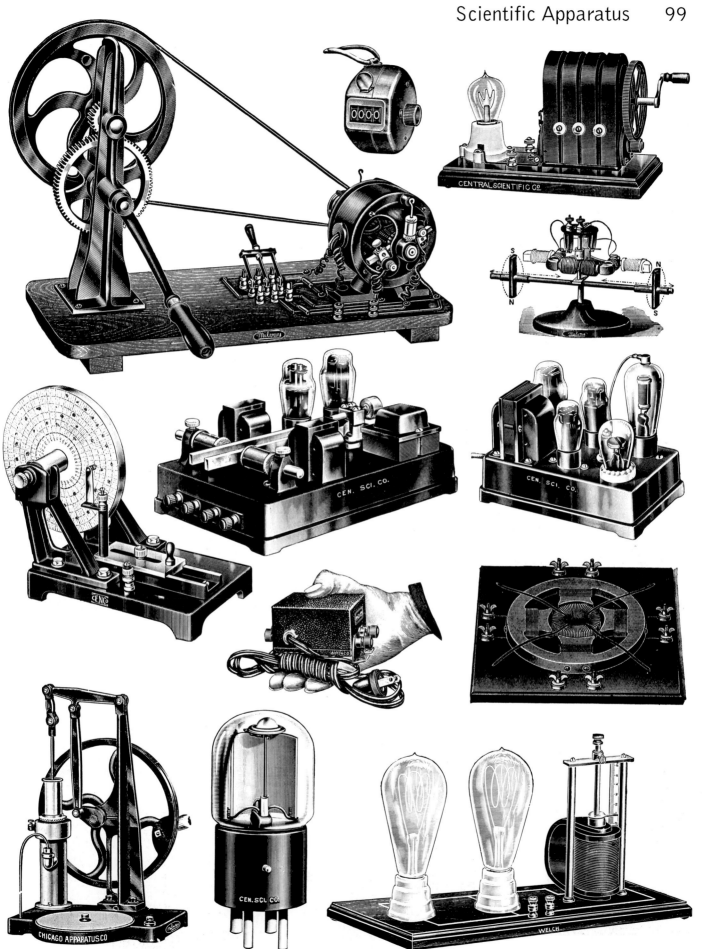

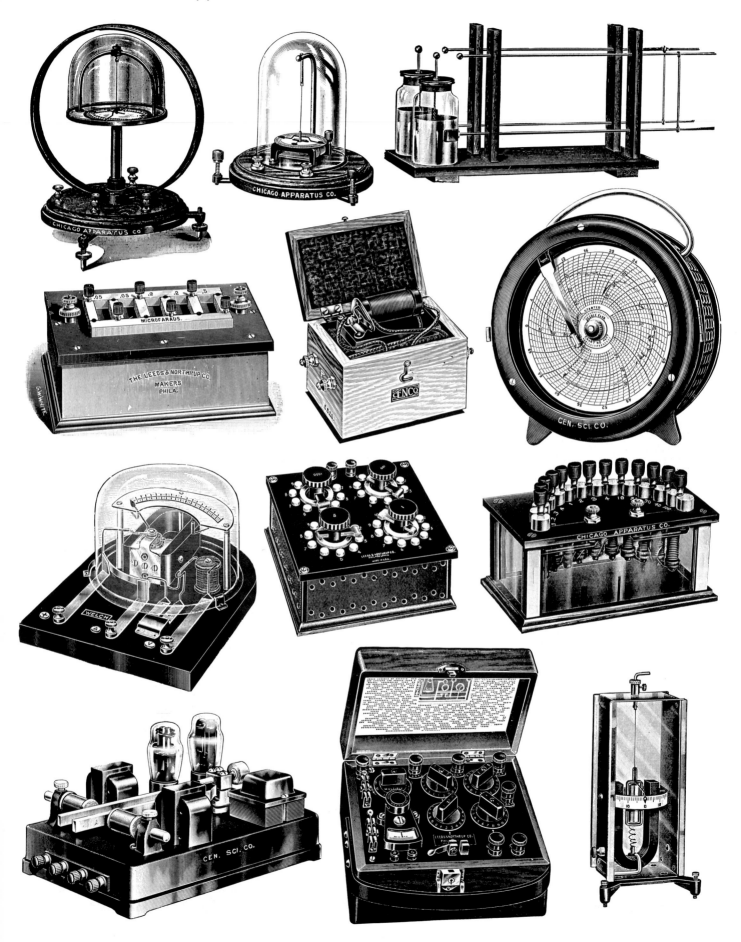

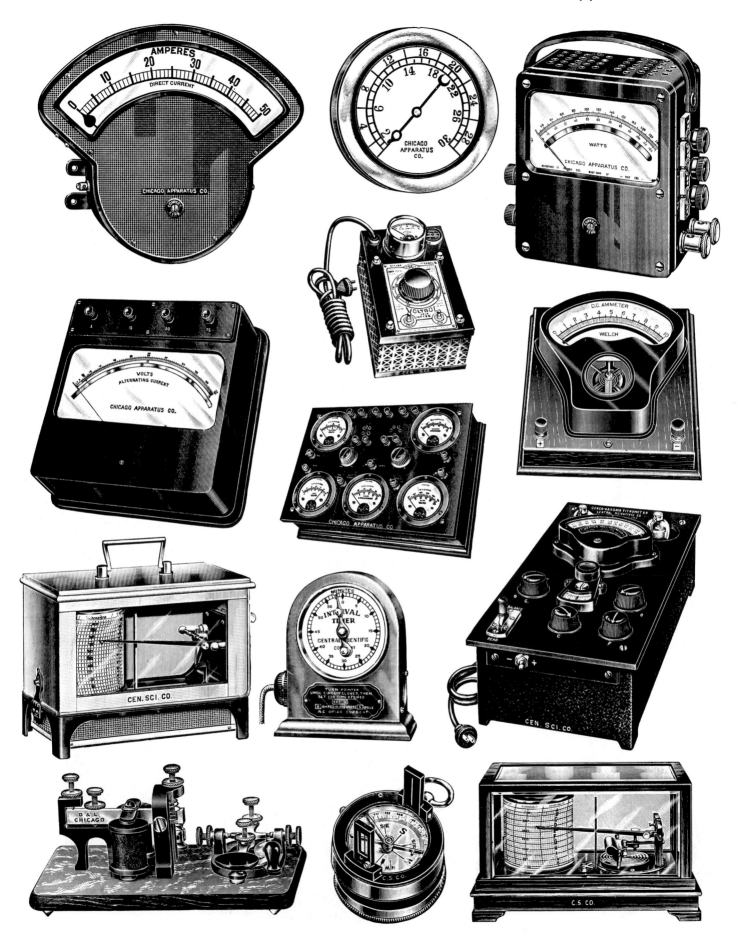

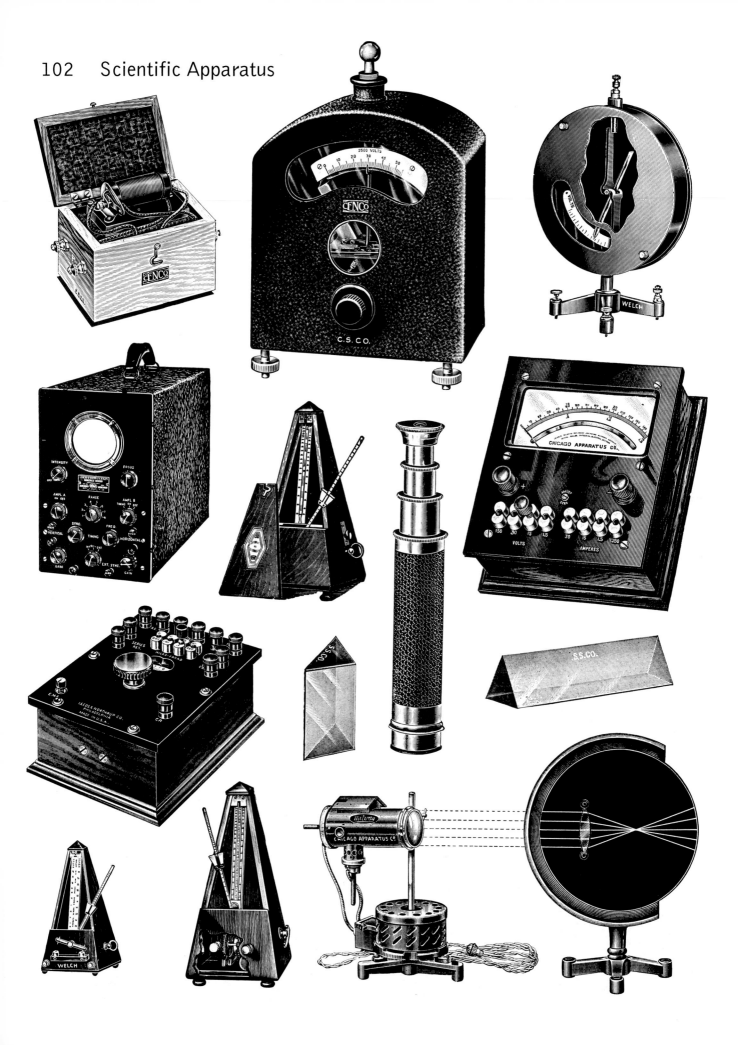

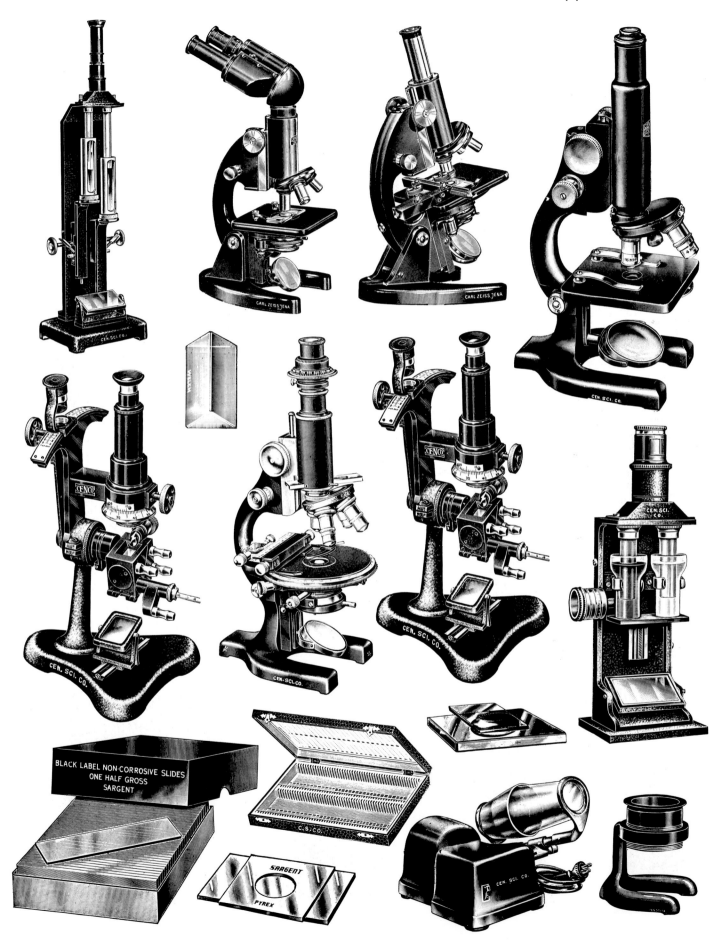

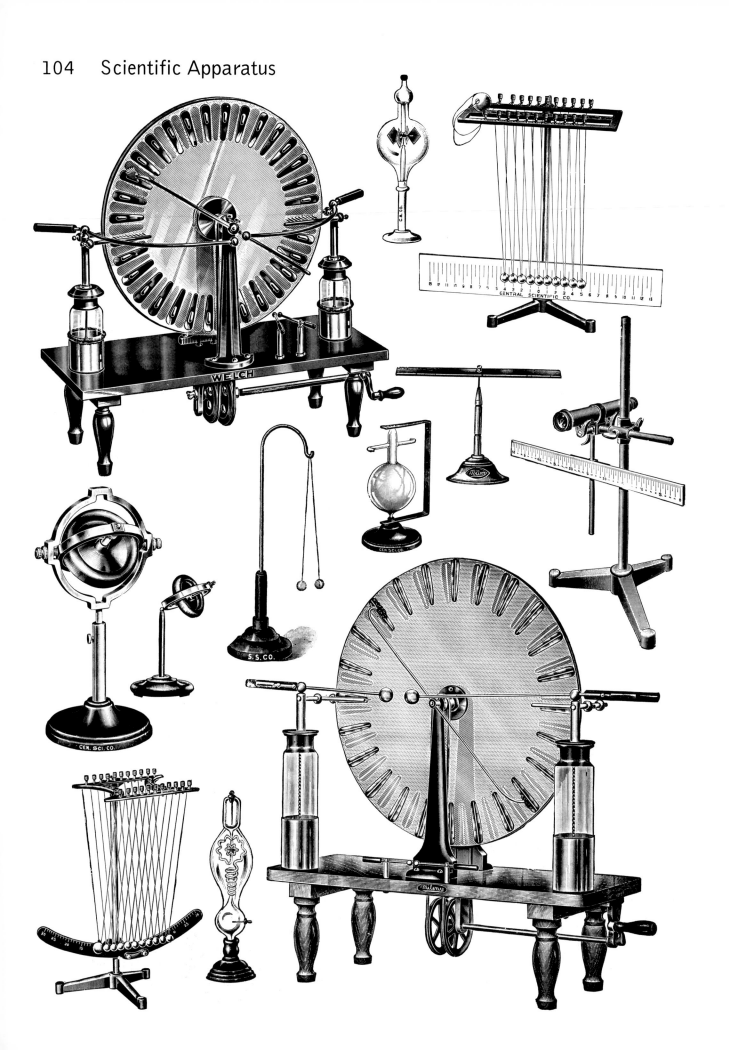

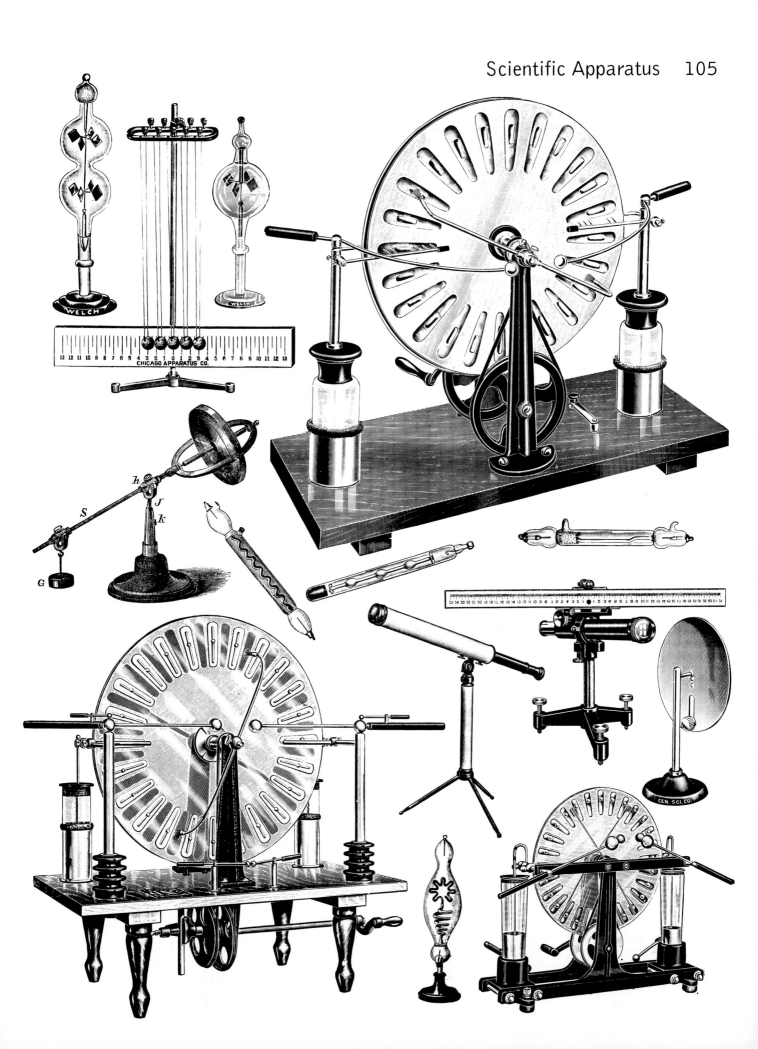

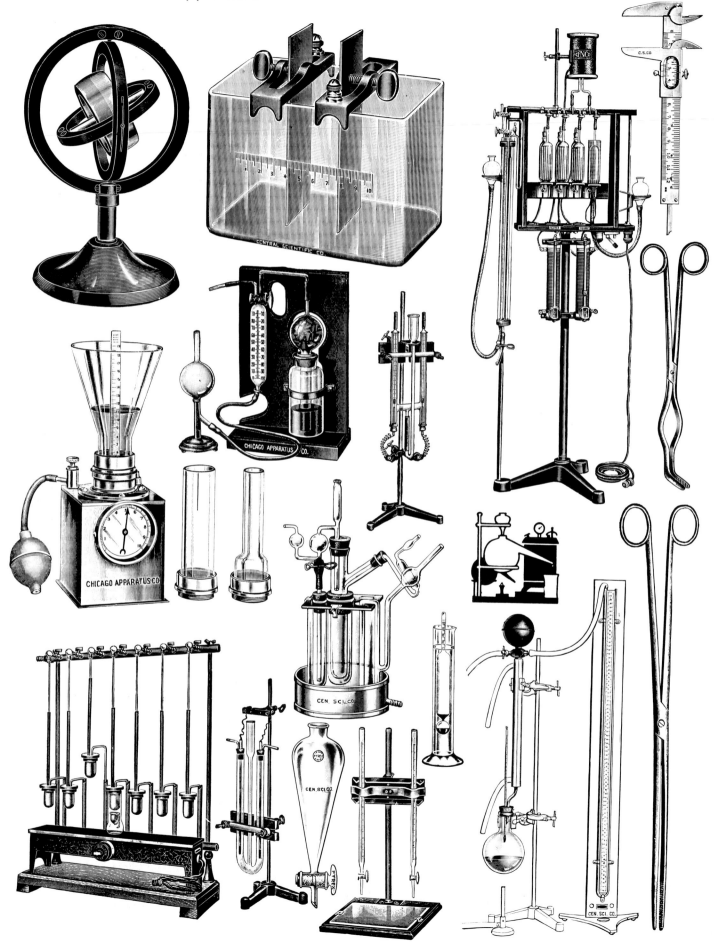

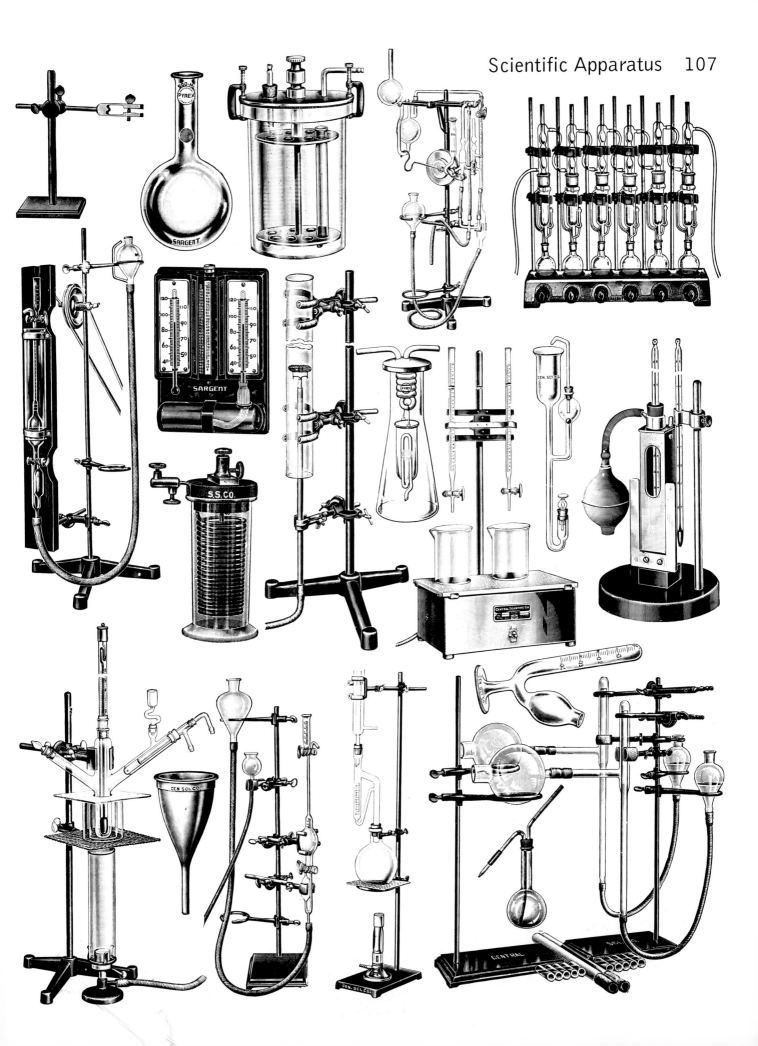

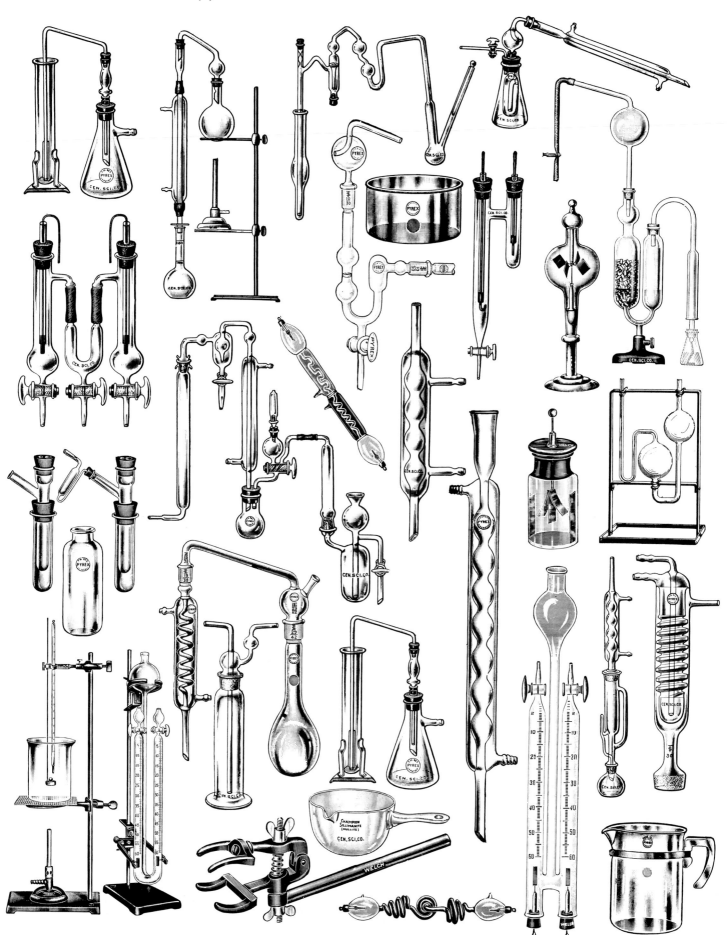

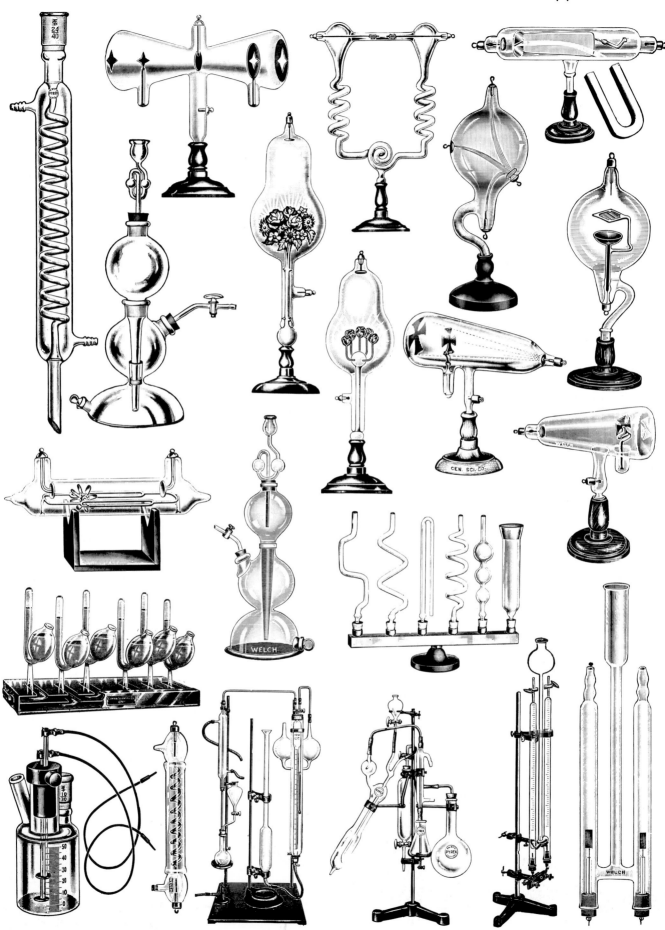

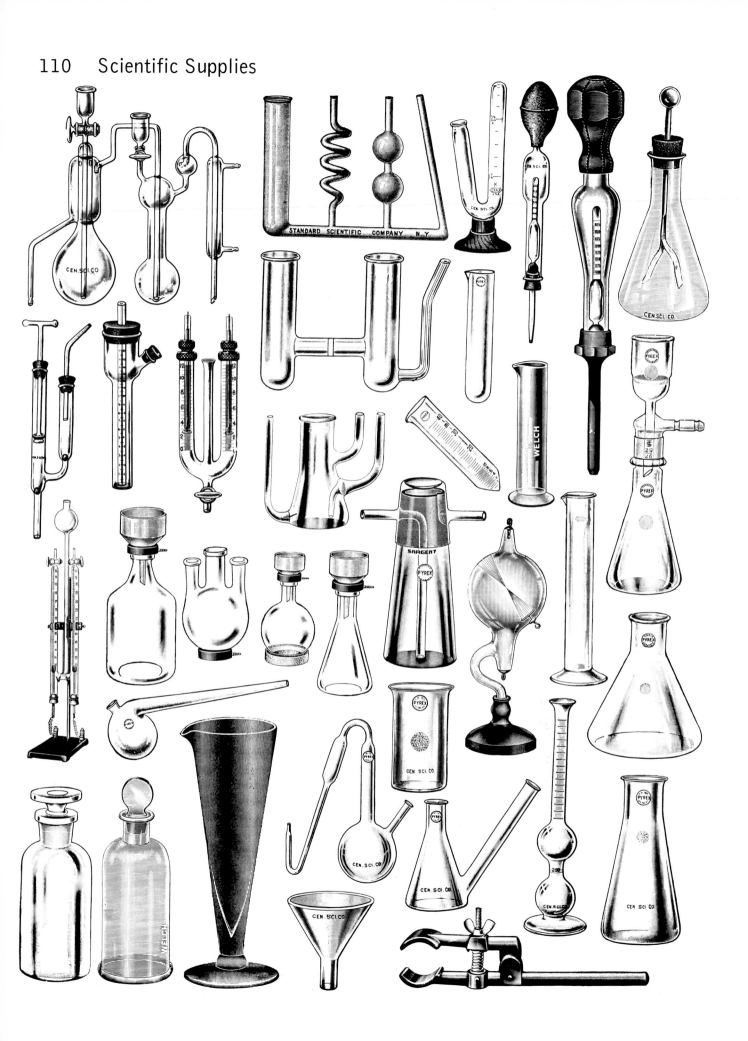

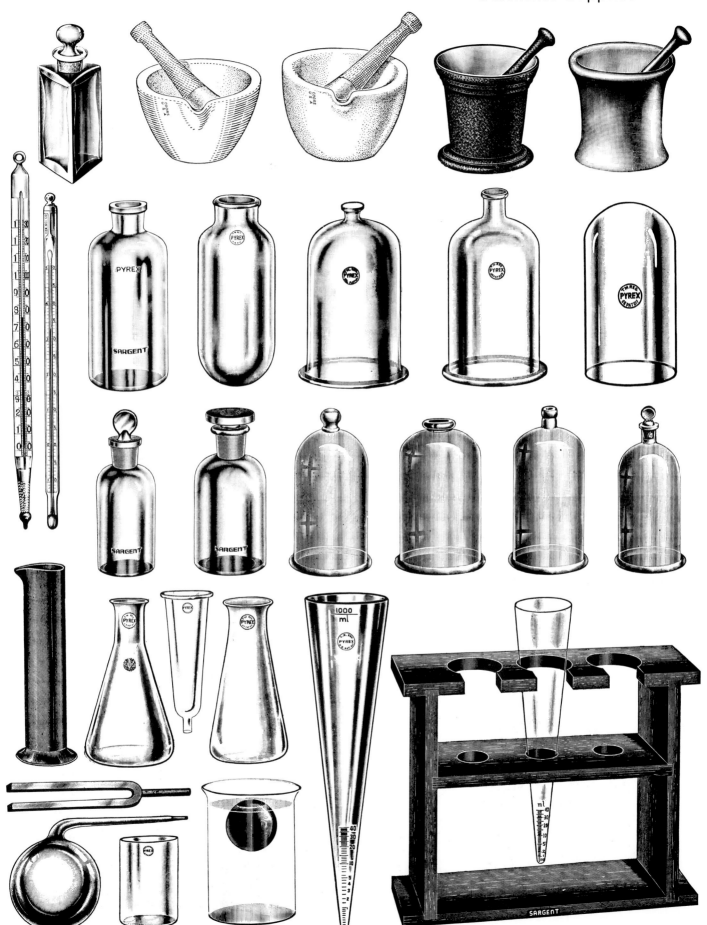

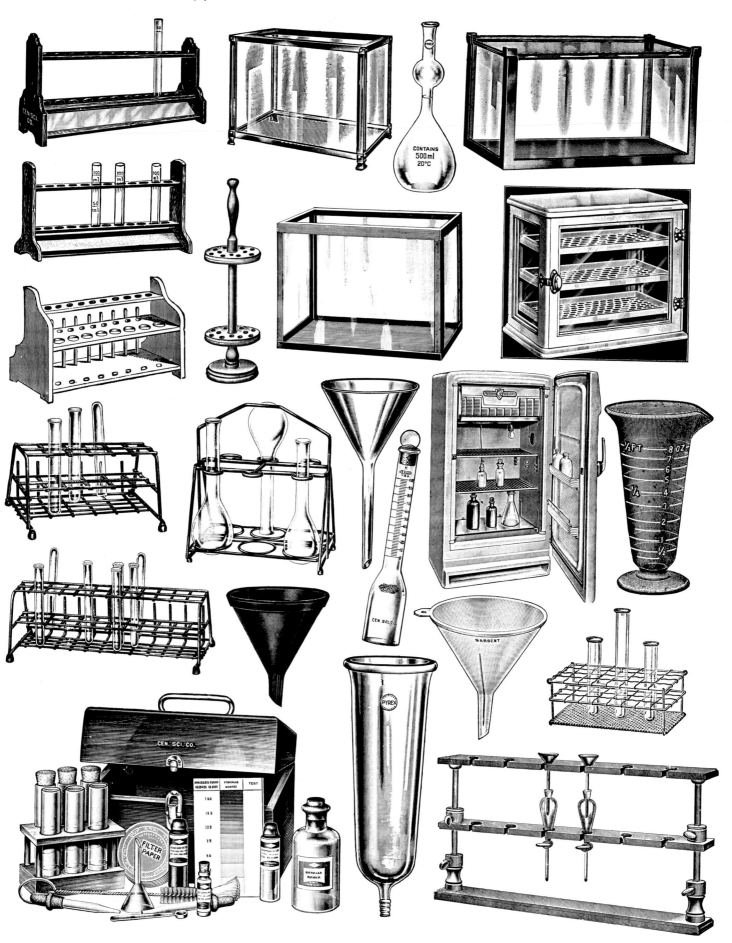

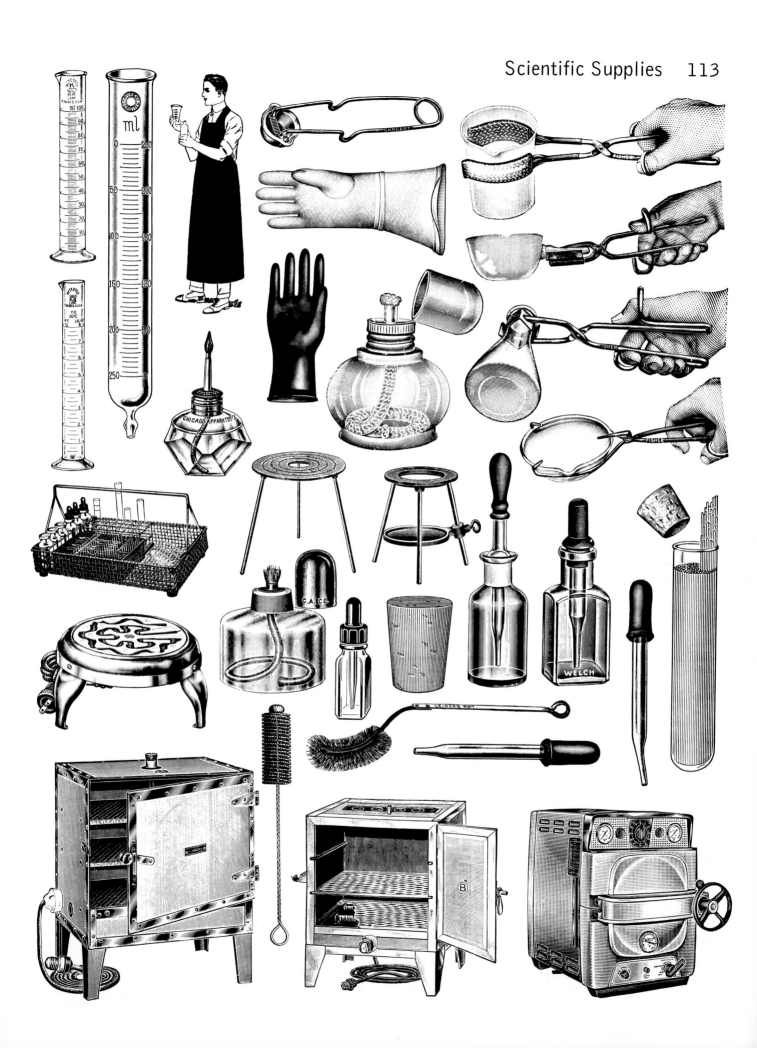

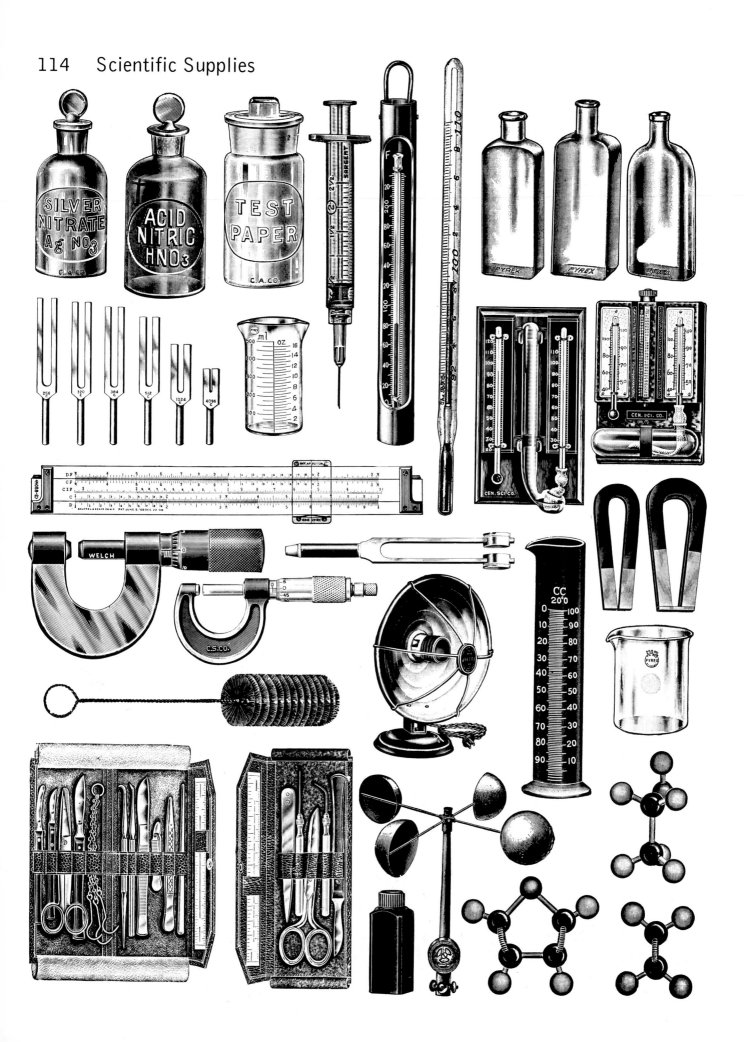

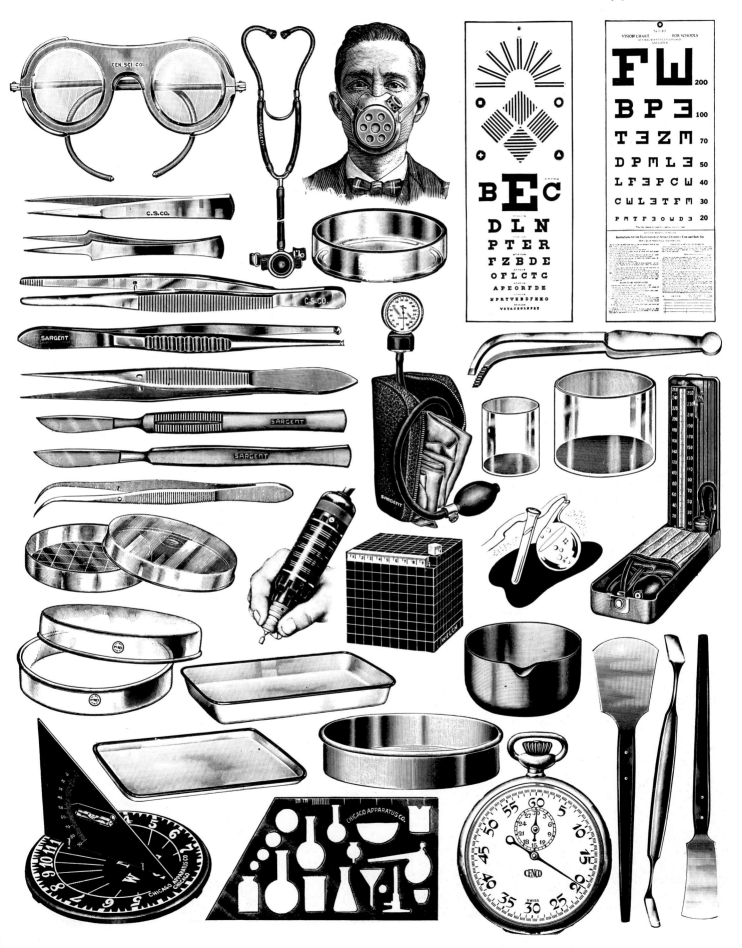

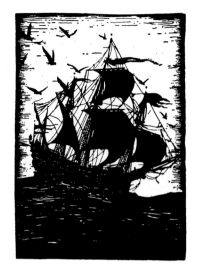

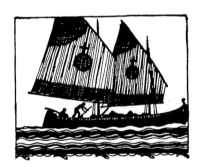

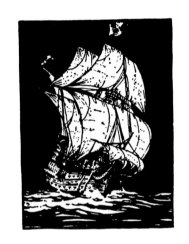

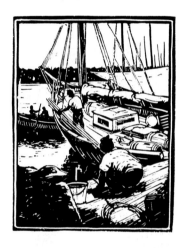

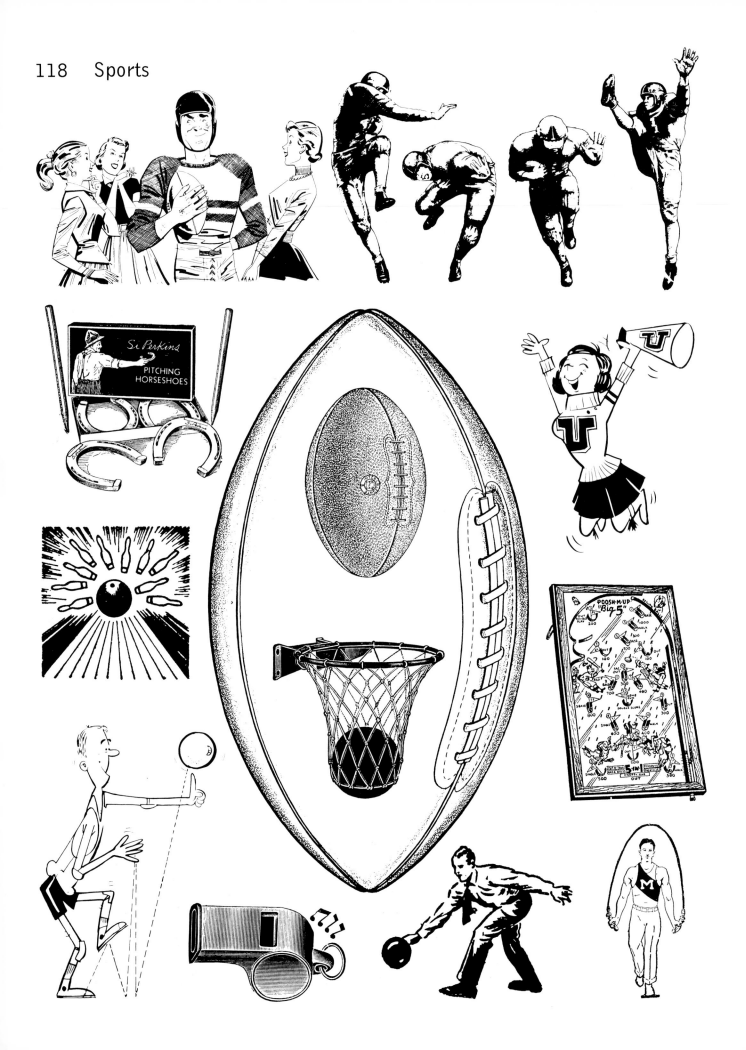

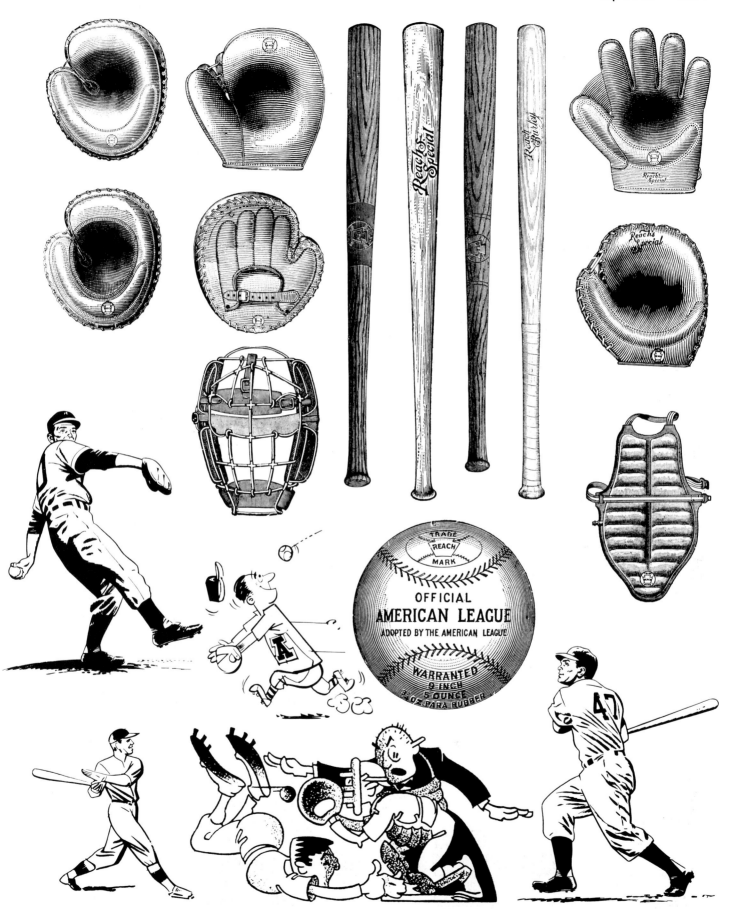

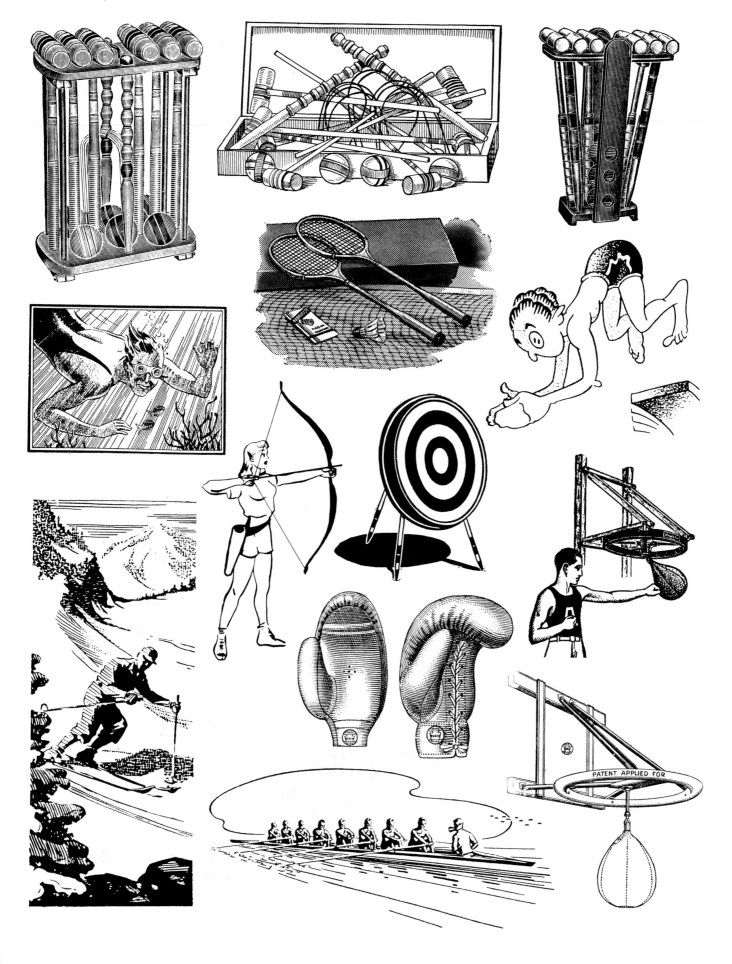

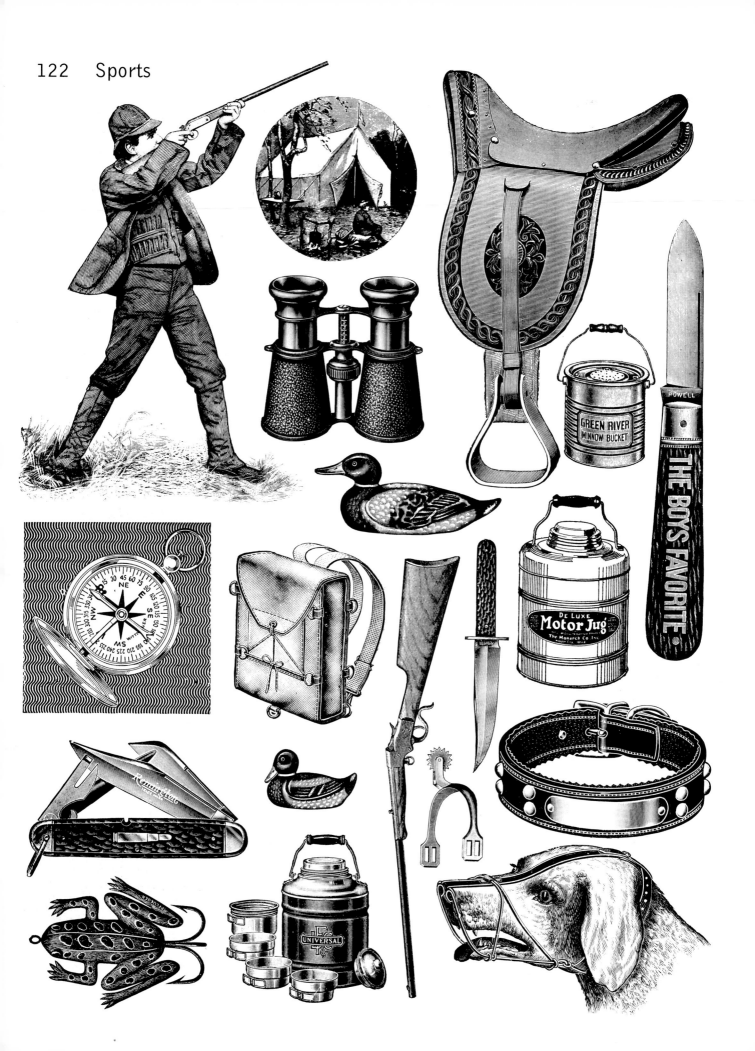

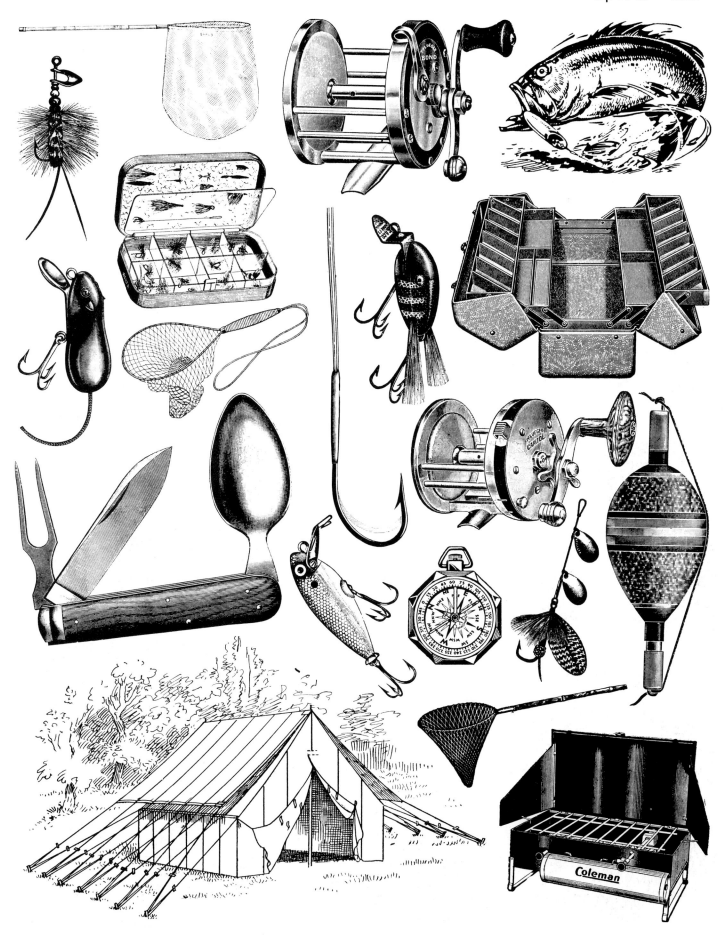

Two-handed Alphabet.

Index